Pays de rêve
The art of the Kronenhalle Zurich

edited by
Sibylle Ryser and Isabel Zürcher

Prestel

Munich · London · New York

Amuse-bouches
5–9

A brief history of the Kronenhalle and its art collection
16–33

Two photographic essays
40–57 | 64–77

Four scenes for the Kronenhalle, with photographic still lifes
10–15 | 34–39 | 58–63 | 78–83

The collection at a glance
84–125

Appendix
126–128

Noblesse oblige

**We have known it for a long time. We have been entrusted with an art collection at the highest level of French modernism, part of a *savoir-vivre* in the best of all senses. What has been lacking so far is a book on the many works of predominantly French and Swiss origin that the former proprietor placed in our restaurant and bar. We are pleased that *Pays de rêve* now fills that gap. It responds – accurately and without blandishment – to the quality inherent in all operations at the Kronenhalle. Through contemporary imagery and various written voices, this book celebrates the riches of the collection and evokes the encounters and friendships directly reflected in the works. Our wish was to shed fresh light onto the fixed backdrop to the ever-changing gatherings at our tables.
You are invited, dear reader, to discover the Kronenhalle anew.**

**Peter Beglinger
President of the Hulda and Gustav Zumsteg Foundation**

Pays de rêve

There is no meal without art. Here all table talk, whether it takes place at a birthday dinner, a family gathering, a tête-à-tête or a business lunch, expands into a view over landscapes, portraits and still lifes. At Zurich's Kronenhalle, a long tradition of sophisticated hospitality unfolds in the natural presence of the greatest works of art. Time and again, the restaurant has been honoured by famous guests. For decades, artists, writers, singers and actors have lunched and dined at the Rämistrasse establishment, raising a glass to exhibition launches, new titles and premieres.

This book focuses on the art. By illuminating a backdrop of personally dedicated works and photographs, we explain how the legendary hostess Hulda Zumsteg together with her son Gustav, a silk merchant and art collector, succeeded in creating a place that to this day unites the pleasures of the eye with those of the palate in such an intimate way. While Hulda Zumsteg was passionately engaged in cultivating appealing cuisine and close contact with her countless guests at Rämistrasse 4, Gustav Zumsteg was fighting for the highest quality and elegance on

the catwalks of international fashion design at the helm of his silk trade company Abraham AG. And on close inspection, it was not merely a lack of space in Gustav's private apartment that led to many a select work from the French modernist period finding its long-term home at the Kronenhalle. It was much rather due to the liaison between art and daily life that the businessman and art lover learned to appreciate in Paris and the south of France – and upheld as a timeless principle in the Kronenhalle too.

Long before the guests arrive and after they have left, the works remain in place. It is stipulated in Gustav's will that they stay. When a beam of light lifts them from the dark at night, they become the secret protagonists of a play that, when daytime comes, is continuously modified by new scenes at the tables. And before the Kronenhalle opens its doors, they watch over the dark parquet floor being polished, table linens unfolded and silverware carefully placed. These thoughts informed our concepts for the imagery in Christian Flierl's

photo essays. Together with the photographer, we searched day and night for angles that would capture the festive magic and lasting poetry of this collection that is so seamlessly integrated into everyday life.

The still lifes of Donata Ettlin also tell of encounters between art and gastronomic culture. Ettlin's focus on light reflected on glass or cast from pleated lampshades also conjures up the presence of the works. Her poetic play between blurred image and definition reveals the attention to detail upheld at this address. Her close-up photography is accompanied by four texts by contemporary authors, who each make the Kronenhalle their starting point for a narrative scene. Renata Burckhardt's protagonists run along the walls in a rapid dialogue evocatively revealing their longings and desires. For Michael Fehr, a landscape with a courtyard and trees turns from a place of polite ritual into one increasingly out of control, a gateway to a fantasy that eradicates all courtesy and morality. Ariane Koch chooses the company of 'Captain O' to undertake time

travel on the increasingly rocky deck of *MS Kronenhalle*. Reto Finger's dialogue between Hulda and Gustav Zumsteg is in fact two monologues, a subtle piece of fiction, in its original version artistically defamiliarised in Bernese dialect.

"I am taking the liberty of sending your mother a gouache that I am dedicating to her with all my heart," wrote Joan Miró to his friend and supporter Gustav Zumsteg on 28 December 1962. This seasonal greeting points to the commitment with which the collector related to the artists and creative minds of his time, a commitment he shared with his mother Hulda. In the same letter, Miró calls the Kronenhalle a *pays de rêve* – a land of dreams – and thus gifts us the title for this book.

Sibylle Ryser and Isabel Zürcher

10

Renata Burckhardt
The visit
Money, sex and religion
are best not talked about

POWER (Money)

Adrian Buyger
Irene Buyger, Adrian's mother, an art lawyer
Adam Passio, an architect, fat and older

Irene and Adrian are sitting at the table by Feininger's "Manhattan".

Irene Don't look, Adrian. It's Valerie.

They stare intently at the picture. Valerie slips past the table.

Irene Don't make it so obvious: talk to me!
Adrian I love the intimations of escape. How it draws the eye towards the horizon and then, en route: freedom!
Irene And don't droop your head like that.
 It's a terrible look.
 Ah, Adam's here, too.

Adam arrives at the table.

Adam Irene. Of course.
Irene No need to kiss my hand, Adam.
 You're *almost* looking good.
Adam With company, I see.
 Your new love?
Irene Sadly not.
 My son.
Adam Adrian!
 I hardly recognised you.
 Even kids with silly names
 grow up, eh?
Adrian Who is this, Mum?
Irene He was sort of your father when you were small.
 And when he was still attractive.
 Who's the host today, Adam?
Adam No idea.
 Good spread, though. What more do we want?
 What's the Japanese woman doing here?

Irene Squinting? *They laugh.*
Adam Vicious! *They kiss.*
Adam See you later, my love.
Irene Off to see Brigitte and Isadora?
Adam You know me, Irene: faithful.
Whatever else changes, I can always count on them.
Irene You won't know from those two nudies what's going on up here, though.
The speech, the occasion, a birthday... whatever this little gathering is about.
Adam Surrender to desire and you forget all these worldly concerns.
Do you know what I love so much about Isadora?
The way she flirts with me. Sometimes her coat's wide open, sometimes less. She tempts me, and then she shuns me.
Just what we men go for, right, Irene?
And HER breasts will never sag.
Rodin: genius.
Irene Adam: odious. Which you've always been.
Just not always quite so fat. *They laugh.*
Adrian Stop it!
Adam There's no life without strife, young man.

Adam goes and sits with the Bonnard and Rodin nudes in the back of the room.

Adrian *Still studying the Feininger* The buildings almost seem to be tipping over. The streets, the canyons, the perspectives: there's no comfort here. No familiarity of the everyday.
It's bleak... bleak... bleak. 1940. The world is in tumult. But the city lives on. It's dynamic. And soon there'll be a new beginning. A new world! The new age is coming.
This picture gives me hope, Mum!
Mum? Wherever you look – up or down – there's change.
There's life.
Irene New York is dead. Nobody needs to have lived in New York.
Everything's everywhere today. Want to see the world?
There's no better place than here *(gestures all around).*

Adrian There's nothing big and faraway here.
I want to breathe foreign air!

Irene Then go.

Adrian It costs money. And Mum, you have so much!

Irene Will you be quiet! Honestly, talking like that...

Adrian I'll pay it back.

Irene When? When you make all your millions from your art?
Ha! *Roars with laughter*
Such a bad idea bringing you along.
Every time we sit by this picture it gets you down.

Adrian Down, and how! As the Gotthard Post! As Koller painted the horses! I'm the horses! The coach! The whip!
Yes, I need to crack out, too!

Irene The Feininger I'm talking about, you dolt.
And what you need is a shrink.

Adrian Crazy is what you HAVE to be!
I'm that Giacometti bird, fat and locked in.
I'm that Lautrec bird, hanging limp and lifeless from a nail.
Is that what you want, Mum?

A demonstration is heard outside. Slogans are shouted.
None of the occupants react.

Irene Shh.
Look: that Japanese woman is getting up.

Adrian She's Chinese!

Irene Look at those bow legs! What's she doing here?
Is she going to give a speech?
I don't believe it: she's giving a speech.

Adrian The comfort of anonymity. Feininger knew all about that, Mum.

Irene Be quiet.
Look at the Chagall. Or the landscapes, that'll calm you down.
Or you'll really start going gaga.
What does Slitty-Eyes want? *She gets up, agitated.*
And what's that Valerie giving her? I don't believe it!

PASSION (Sex)
Adam Passio
Rose Passio, his much younger wife, a fashion designer
Valerie Folle, an artist

Rose and Adam are in the back room, with the Rodin and Bonnard nudes.

Rose	What are we doing here?
Adam	We were invited.
Rose	Invited! That's all you care about.
Adam	I have to escape the everyday or I'll die.
Rose	This is your everyday! Your living room, where you can gawp at your Isadora. Leaning back, just happening to open her coat, her eyes all coyly closed. That gets you going, doesn't it. Dying's about the only thing that'll drag you out of here. And then at home you can't get anything going. But I want sex. Good sex, too.
Adam	What's got into you? Shut up! I shouldn't have brought you. You and alcohol don't mix.
Rose	I want passion! I want to be in love!
Adam	Be my guest, my dear, be my guest. What's that Japanese woman doing over there in the brasserie?
Rose	She's Chinese. You really have no idea, do you. Especially about love.
Adam	Go and fall in love. Be my guest!

The demonstration gets rowdier. Megaphones, sirens. The occupants remain unmoved.

Rose	OK, I'll tell you. It's Braque I'm in love with. That white hair, soft as feathers.
Adam	You need to choose your partners a little more carefully, Darling: he's dead.
Rose	My emotions versus your logic.

But I'm not going to let you take anything else.
A man who can capture beauty like that. A man who knows the warm light on a field. A man who sees such colours: that, Adam, is a man worth loving.

Adam Well, at the risk of overdoing the logic again: you won't get much sex from him.
Rose That's up to me.
Adam Pity you're too young for Cyber. You're dynamite in the sack.
Rose Compared to you.
Adam Come off it: you're living in the past.
You're old now.

Valerie arrives.

Rose Valerie! How are you?
Valerie Strolling. Looking. Reading: Ernst, Giovanni, Johannes, Hans, Max, Reinhold, Augusto, Robert, Ferdinand, Adolf, Marc, Joan, Pablo, James, Friedrich, Willi, Conrad, Gottfried /
Adam Not that gang again...
Valerie I'm not talking to you, culo!
Hombres, solo hombres!
Don't you get it, Rose?
Rose Valerie, it's a private collection.
And there IS a woman: Anna Keel!
Valerie A soda siphon and a guy in profile. Hah!
Rose Oh, Valerie /
Valerie Hey World! That's what you have to say, Rose.
It can't go on like this. The same pictures, the same comments, the same old hombres: NO!
Adam It's tradition, Ladies. Get used to it.
We all need tradition or we'll all go loco.
Valerie Wow! Hah! Right! NO! Everything's going to change: right now!
Rose Valerie, you're like that Gubler of himself: restless, driven.
Do you want to end up crazy like him?
Valerie And you, Rose? What about you?

Rose	Be like Picasso over there. Put a stripy sailor top on, be proud and paint! Or get yourself some professional help.
Valerie	You're like all the others.
	All this city thinks about is shrinks.
	As if you can just talk it all up and iron it all out. Well I say NO!
	Whispers: But do you know what's funny, Rose? This is my last day today. I can feel it. My last evening. And THIS is where I'll have spent it!
Rose	Valerie! It was Joyce who had his last evening here, not you. You really are losing it.

Valerie leaves.

Adam	Why is she speaking Spanish?
Rose	I'm worried.
Adam	Forget it.

Paving stones hit the walls and the windows. Only Rose reacts briefly.

Rose	What's going on? Do something, Adam!
Adam	There's always something going on out there.
	Look: the Japanese woman has got up.
Rose	She's Chinese.
Adam	Is she going to give a speech?
Rose	Adam, by the way: I can't look after Lou any more. Will you?
Adam	Do I have to?
Rose	Maybe she could stay with my cousin. She's broke and could do with the money.
Adam	How old is Lou now?
Rose	Twelve. She's in Fifth Grade.
Adam	Almost grown up. That should work.
	And where do you want to go, my love?
Rose	To the coast, where Braque was.
Adam	Go ahead.
	But the picture's a cornfield, not a beach. You can see that, right?
Rose	You're such a pedant.

Adam	Hey, what IS that Japanese woman saying?
	What DOES she want?
Rose	Chinese!

They listen.

Rose	She says the Kronenhalle's being sold.
Adam	Sold?
Rose	And she – Li Zhang Cai, she's called – is buying it. And it's going to be vegan fusion cuisine: healthy, light and fair.
Adam	Fair??

Windows shatter. Nobody reacts.

Adam	*getting up, enraged* Is she out of her mind?
	And what the hell is Valerie doing there?

MADNESS (Religion)
Valerie Folle, artist
Li Zhang Cai, manager
Guests

All the guests are standing in the brasserie in an angry huddle. All the tables are vacant. Valerie speaks, while Li Zhang makes friendly exaggerated accompanying gestures.

Valerie	Friends, it's so wonderful to see you all here!
Rose	Valerie, what are you doing there? Come back!
Adam	Valerie, come here!
Valerie	A synthesis of a hundred realities: that's our Kronenhalle, right?
All	Yes!
Valerie	All our pictures!
All	Yes!
Valerie	Let's look at them all with all our love!
All	Yes!

Valerie Can a synthesis like this ever be dissolved?
All No!
Valerie The synthesis is sacred, right? A religion, right?
All *enraged* What? What was that? No, no!
Valerie But it CAN be dissolved, totally.
And I will tell you how.
Our loves will all go their separate ways.
And I will help them find new homes.
Adrian Look! Chagall, the blue: THAT's the faraway, the views, the distance!
I suddenly feel so light!
Valerie Yes: our loves will find a freedom of their own.
With your help, maybe.
Because all these pictures are now for sale.
We're blasting the past! Ha! And soon we'll have the future hanging here.
From China, Borneo and Kyrgyzstan. Topical, critical, integral, digital, global. Yes!

The crowd leap on Valerie, whose further words are lost in the mêlée. She falls and is crushed. Li Zhang flees. Police, tear gas and breaking windows.

THE END

Renata Burckhardt (*1973, Bern) studied at the Academy of Art and Design in Basel and completed a Master of Advanced Studies in Curating at Zurich University of the Arts. She lectures in art history, language and theory, and is the author of several plays and short stories. She writes a culture column for *Der kleine Bund* and initiates staged interventions in theatres and exhibition halls. She was assistant director at the Deutsches Theater in Göttingen and has been the recipient of the *Dramenprozessor* and Marlene Streeruwitz Masterclass theatre fellowships and other literature prizes and grants.

15

Kronenhalle, art, couture
A brief history of the Kronenhalle and its art collection

Various circumstances have paved the way for the Kronenhalle to become a destination for art lovers. One of them is the fairy-tale biography of a particular woman: Hulda Zumsteg, who at the age of 16, just as the last century began, made her journey from Winterthur to Zurich with just fifty *rappen* in her pocket – and at the age of 80 was established as the proud 'mother' of more than 70 staff at the restaurant's premises at Rämistrasse 4. Another important factor was her entrepreneur son's enthusiasm for all things beautiful. Gustav Zumsteg was inherently alert to the sensual stimulation of painting and truly grateful for the early trust artists bestowed in him during the fall of France and the post-war years. His friendships granted him access to galleries, studios and the intellectual elite of France and Switzerland; personal and professional contacts the son naturally shared with his hostess mother when in Zurich.

The Kronenhalle's reputation as a legendary meeting point was endorsed by the fact that Zurich became home to many who were politically ostracised during Europe's wars. Driven from their own countries by ideological repression, they would identify all the more with the simultaneous artistic awakening – and find like-minded friends in the convivial atmosphere created by the restaurant's true art of hospitality.

The following pages gather several narratives that came together in the making of the Kronenhalle's art collection. The role of fashion cannot be ignored, as it demonstrates the level of ambition Gustav Zumsteg dedicated to beauty and elegance during his time in the silk trade. Flowers in the brasserie – and flowers featured in its paintings – have added to the glamour of the address. And above all, a bountiful generosity continues the tradition of the house in a sensuous liaison between art and cuisine.

The knight Rudolf Brun managed to unify all workmen unanimously against Zurich's noble councilmen. With the guild revolution of 1336, he established the guilds' political influence, and could proudly announce himself "First Mayor of the Republic of Zurich".

The writer Conrad Ferdinand Meyer (1825–1898), one of Kronenhalle's early guests, portrayed by Karl Stauffer-Bern in 1887.

The Kronenhalle (centre) was built in 1842 as a three-storey residential edifice with an elevated ground floor. At the time, the lake port was located right in front of the building and its stables. The sunny lakefront Sonnenquai with the Hotel de la Couronne (left) at today's Bellevueplatz soon attained their central functions.

Around 1900
On close inspection, we can still see that the Kronenhalle was not conceived as a restaurant from the start. In 1842, prior to the backfill of the lake that created today's Bellevueplatz, the property was built as a residential house with a barn and shed, also in order to accommodate the elegant neighbouring Hôtel de la Couronne with space for its guests' carriages. As of 1862, it became a restaurant and, with its position on the lake, a meeting point for Zurich's high society. Arnold Böcklin and Gottfried Keller dined here when 'lunch with soup, meat, vegetables, cheese and pudding' cost just 1.50 Swiss francs. And Conrad Ferdinand Meyer may also be counted among the witnesses of early literary exchanges taking place at this address.

1924
Gottlieb and Hulda Zumsteg purchase the Kronenhalle, and move from the Mühle in the lower Old Town to the fringes of the Old Town. Having been unoccupied for several years, the property is derelict. Only great personal commitment allows the Zumstegs to unearth and continue the tradition of the place whilst creating a new client base. "Substantial new acquisitions such as table linen, dishes and silverware had to be made as well, because from the beginning I insisted on everything being of first quality and always in impeccable order." Hulda will always remember the years after the war: "for Zurich, it was a time when money was earned easily and spent just as easily."

A decorative frieze above the brasserie's wooden wall panelling shows the emblems of the traditional Zurich guilds as well as new guilds formed upon Zurich's expansion. Yet the Kronenhalle never functioned as a guild hall. The restaurant's nod toward Zurich's guild society is rather based on the annual ritual of the guild-gathering Sechseläuten which brings its gregarious after-party here every spring.

Gustav Zumsteg refused a career in the restaurant of his mother and stepfather. From Ludwig Abraham, he learns more than the craft of the businessman. His affinity for top-quality silk fabrics will grant him access to the most important haute couture designers.

The guest books clearly show that not only theatre and opera celebrities but also artists and graphic designers found their way to Kronenhalle. Hans Fischer, the illustrator of the famous children's book *Pitschi,* for example, reflected on what it means to dine in private under the proverbial "four eyes".

1931 Hulda's son Gustav is by now 16 and pondering a career in hospitality. In the studio of his mother's tailor, however, another passion is soon aroused: "nothing came close to the taking hold of a piece of silk." The fine fabric is to become his profession and calling, and he starts a business apprenticeship with L. Abraham & Brauchbar Co. Seiden AG. As a so-called 'converter' business, the company designs fabrics, commissions select Swiss factories for their production, then distributes them to retailers and individual designers. By producing printed silk for haute couture and prêt-à-porter, Gustav will turn Abraham into a leading global label for exquisite fabric design.

1930s Comparing the seasonal programme of Zurich's main art museum, concert hall, theatre and opera stage with the Kronenhalle's guestbook proves that by the 1930s the restaurant has developed into a melting pot of cultural bohemians and the social elite. Whoever finds a home in Zurich's music, literary or art scene, finds in Rämistrasse 4 a place of lively exchange and contemporary debate. Café Odéon, once a meeting point for the Dada circle and situated just across the road, also remains a favourite spot amongst the town's artistic celebrities. A stone's throw away are the music theatre (today the Opera House) and the Pfauen theatre at Heimplatz (today called Schauspielhaus), whose anti-Fascist programme is able to withstand violent animosity thanks to a shareholder company founded in 1938. The Schauspielhaus thus starts writing history as a stage for émigré artists; its ensembles are always loyal guests at the Kronenhalle.

The private estate of Gustav Zumsteg included "one of the very few American pre-war artist's books". His 1935 edition of *Ulysses* unites the author James Joyce (right) with the artist Henri Matisse; two of Gustav's early and important references.

"Pour Gustav Zumsteg, le 3 février 1954," is what Georges Braque wrote on the print of his portrait. The contact did not come about by chance; the important French artist was also a friend of Aimé and Marguerite Maeght.

1940 Every so often, tensions between war experiences and the proud hospitality are transcended by an entry in the guestbook. *"Après une guerre aussi douloureuse, on croit rêver en se retrouvant à la Kronenhalle dans un pays aussi sympathique,"* notes for example the orchestra director Ray Ventura on 4 November 1940. It is also the year in which Gustav, together with friends, tries to enable James Joyce to migrate from France to Switzerland. Joyce and his wife Nora had found refuge in Zurich during the First World War, and they remained loyal guests.

1943 As head of the Paris franchise of Seiden AG L. Abraham & Co, Gustav discovers his spiritual home in French culture. Here he finds the inspiration to create his own designs whilst pursuing his business obligations. He starts reading History of Art part-time at the École du Louvre, visits museums and galleries, and lets traditional and contemporary visual arts concepts inform his textile designs. Following a recommendation, he meets Aimé and Marguerite Maeght in Cannes, where the lithographer and future publisher had founded his own printing house in 1930. Pierre Bonnard orders a poster to be printed by Aimé Maeght and finds him to be an exceptional colourist. The encounter marks the beginning of many collaborations with artists, amongst them Henri Matisse, Georges Braque and Joan Miró.

It was Pierre Bonnard who encouraged the young lithographer Aimé Maeght to dedicate himself to contemporary art and act as a publisher of print editions, and Gustav Zumsteg was in direct contact with the painter from early on. This view from a window onto a cloudy sky was sold in 2006.

The Maeghts named their prints shop on rue des Belges in Cannes 'Arte' after the business started to give art works more prominence.

This 1944 advertisement in *Labyrinthe* with a graphic by Georges Braque is an early indication that the Kronenhalle was already invested in French contemporary art during the Second World War.

"We were all young then and without money," Gustav would say retrospectively. "We would forge our careers only later. The Maeghts with their pictures and I with my silk." The friendship between Maeght and Gustav is based on their mutual respect for the visual arts. Maeght does not shy away from any printing experiment that allows the printed product to do justice to artistic expression, and Gustav labours meticulously on translating aesthetic visions satisfactorily onto silk. Gustav starts collecting art.

Meanwhile, Hulda is keeping a keen eye on all guests, including those who cannot afford to eat from a menu in lean times. "There was a students' table during the Second World War, at which everybody drank a lot of beer but ate only very little. This couldn't be good for those young stomachs! I went to the kitchen, had them prepare a big pot of meat soup, added a few chopped sausages and offered it to the youngsters." Most of them would eventually grow into men "of position and authority". And the meat soup remained a topic of conversation for many years to come whenever one of them lunched or dined at the Kronenhalle.

1944 The third edition of the arts and literature magazine *Labyrinthe,* published in Geneva by Albert Skira, shows the Kronenhalle as an address for art lovers in Zurich. The advertisement combines culinary delights with the sensuality of contemporary French art. "Beautiful paintings, superb food and friendly faces – what more could one want?" asked Klaus Mann, who was here in the autumn of 1945. A sophisticated meal among masters is not without impact at a time when even Switzerland is preparing for a food shortage and planting potatoes on balconies, in courtyards and in gardens.

Galerie Maeght's first Paris exhibition took place in December 1945 and was dedicated to Henri Matisse. It gave an overview of the mature artist's oeuvre, featuring paintings, drawings and sculpture.

Christian Bérard (left) was a respected painter, illustrator, stage designer and outfitter in the creative scene of Paris. It was he who recommended that Gustav adapt his creativity to the needs of Parisian haute couture. Here, we see Bérard working on the costumes for Jean Cocteau's film *Les parents terribles* (1948).

1945 During the war many artists left occupied Paris for the south – creating favourable conditions for an emerging market in the works of Classic Modernism. For the opening of their Paris gallery in rue de Téhéran, Aimé and Marguerite Maeght show a solo exhibition of Henri Matisse from 7 to 29 December. For Gustav, the Maeghts and many associated artists have become a second family: "I believe I could have become one of the most important art dealers, because at one point I was enjoying the unrestricted trust of great artists. But I avoided dedicating myself completely to art dealing, as I realised I was too shy for it."

Doors are opening for the young Swiss wherever he can share his high aesthetic standards and enthusiasm for art: "It was Bérard who introduced me to *le Tout-Paris* of the time." An admired scenographer, artist, fashion illustrator and designer, Christian Bérard provided Gustav with access to many personalities in the worlds of art and fashion.

In the post-war years, as demand for fine fabrics and desirable gowns was on the rise, Zurich-based Abraham AG delivered to haute couture fashion designers, particularly in Paris. Pierre Balmain's 1950 summer collection aspired to an exclusivity best known in the arts, with models posing in front of contemporary works by Georges Braque.

1950s "For his evening gowns, Balenciaga is using a *cuir de soie* by Abraham that is exciting admiration…" According to the Zurich newspaper *NZZ,* the Paris spring collection of 7 March 1953 is a resounding success for Swiss textile production and fabrics created by Abraham. Gustav's business travels have brought him into the studios of fashion designers in Paris, New York, London, Rome and Madrid. He is working with Cristóbal Balenciaga, Coco Chanel, Christian Dior, Hubert de Givenchy and Yves Saint-Laurent.

Abraham AG is on the international catwalk season after season, adapting to the curves of changing ideals of femininity, making fashion history at the highest level. Designs using Abraham fabrics are dressing celebrities from the cinema and theatre world, politicians and European aristocrats. At ease with a broad repertoire of styles, hints from European modernist paintings repeatedly find their way into patterns and colour combinations.

Kronenhalle's menu, initially characterised by a Bavarian chef, is extended by specialities from Gustav's business destinations, but remains loyal to its hearty core.

In 1957, *Midi. Arbres et rochers* (1952) by Jean Bazaine was at the Kronenhalle (below). Today it is part of the collection at Kunsthaus Zurich.

In 1961, Friedrich Dürrenmatt (left, at the back) was still friendly with Max Frisch (right, at the front). Five years later, at this favourite hangout, he would challenge his literary rival with a legendary blow. After the opening night of Frisch's *Andorra,* he dismissed the play in front of a united gathering of celebrities and theatre critics.

There are many illustrated letters and papers relating to Hulda and Gustav Zumsteg's love for the arts and artists. Some of them today still form part of the Kronenhalle estate; others have found new owners during the liquidation of Gustav Zumsteg's legacy.

1957 Following the death of his stepfather, Gustav takes over the management of Kronenhalle. He calls it "fulfilling a duty". He integrates his growing art collection into Kronenhalle's various rooms, thus establishing "the world's most culinary museum" and a unique "piece of hospitality art". Top works of Classic Modernism such as Henri Matisse's *Les huîtres,* Marc Chagall's *Les Glaïeuls* and Joan Miró's *La table (Nature morte au lapin)* form the background to banquets, family gatherings and business lunches, but also travel as loans to exhibitions worldwide.

1960s An increasingly international fashion, art and design clientele begins to frequent the Kronenhalle. Gustav's artist friends – among them Marc Chagall, Alexander Calder and Joan Miró – are visitors. They immediately gain Hulda's affection too, and respond to her hospitality with picture letters or personally dedicated drawings and graphics. Musicians, sports personalities and film stars become guests; premières like Max Frisch's *Andorra* (1961) and Friedrich Dürrenmatt's *The Visit* (1966) are celebrated here.

Hulda, the *patronne,* occasionally accompanies her son on his travels, learns from other chefs, does her rounds in the brasserie and the halls evening after evening, and watches over her staff, who often loyally support their employer for decades. The sophisticated hospitality creates lasting relationships, the acute attention paid to the wishes of the regulars bears fruit: the Kronenhalle has entered a golden age.

Aimé and Marguerite Maeght at the opening of their Foundation in July 1964.

Within the ensemble of architecture, gardens and art, an entire courtyard is dedicated to Alberto Giacometti's bronze sculptures. Aimé Maeght plays an important role in the promotion of the sculptor, and it is via their Paris gallery that Giacometti becomes part of Gustav Zumsteg's collection.

At the present-day La Colombe d'Or restaurant in Saint-Paul-de-Vence, the regulars are still often guests of the Fondation Maeght – and original art works by classical modernists that have long been part of the interior. Gustav Zumsteg (far right) was amongst the guests at Wassily Kandinsky's opening in 1966.

1964 As a tribute to their son Bernard, who died in childhood, on 28 July Aimé and Marguerite Maeght open the Fondation Maeght in Saint-Paul-de-Vence near Nice. "Something new has been attempted here, the result of which we may not judge, as it belongs to the future," comments French minister of culture André Malraux at the opening of the new destination exhibition space. He adds that Aimé and Marguerite have created a universe for modern art, for the poetry of our time. The foundation defines art as a mediator between nature and architecture, and aims to provide the setting in which contemporary practice can be encountered in a casual way.

"Ceci n'est pas un musée" becomes a dictum and remains the programme of the foundation, which Gustav will continue to follow as a board member for 18 years. Many artists whose works are integrated in the local topography of architecture and nature feature in Gustav's collection too.

In Saint-Paul-de-Vence, a hotel decorates its restaurant with original works. The Colombe d'Or has probably given Gustav an early incentive to bring life and art as close together as possible, to be shared permanently with the guests of the Kronenhalle.

Hulda Zumsteg and Paul Nüesch, chef de bar, in front of Henri Matisse's *Les huitres* (1941).

Where today's select cocktails are served in the muted light of Diego Giacometti's lamps, there was once a hairdressing salon.

1965 The Zumstegs acquire a former hairdressing salon in the neighbouring property. Against his mother's initial resistance – she fears for the solid, civilised reputation of her restaurant – Gustav decides to open a bar. He commissions Robert Haussmann to design the interior, and Diego Giacometti, the furniture. The leather seating and wall coverings are dark green, and the mahogany panelling reminiscent of a ship's interior. Yet it is above all due to the unique cocktails that the Kronenhalle Bar becomes a leading address.

A small leaflet welcomes a public that might still be sceptical: "We greet especially that woman of special stamp who sits here alone in the bar in the early evening, waiting to be joined by her husband before they go out for the evening, enjoying her anticipation. She belongs to the regular guests, as does that small group that comes here for refreshment after concert, cinema, or theatre."

1967 Vis-à-vis their guests and in the eyes of the public, not least due to his own business obligations, Gustav lets his mother assume a front-of-house position. He commissions a large-scale portrait of her by Willy Guggenheim (also known as Varlin). Hulda sits as model in the artist's studio at Neumarkt. And to the present day the 'patron goddess' in her black Balenciaga dress watches over all that happens in the brasserie.

At 77 Hulda Zumsteg has only one day of rest per week. But for her portrait in 1967, she regularly leaves the Kronenhalle to model by daylight for the painter Varlin.

Gustav Zumsteg's donation *La fenêtre sur l'île de Bréhat* (1924) initiates the project of a Chagall room at Kunsthaus Zurich. The cheerful serenity evoked by its landscape is also characteristic of Chagall's friendship toward Hulda Zumsteg.

1970 To mark the occasion of his mother's 80th birthday on 12 November, Gustav instigates a commemorative publication. He utilises the illustrated brochure as an opportunity for a personal tribute. "Thanks to her example, I have become particularly aware that 'serving' is a pleasure and simultaneously a precondition for 'deserving' and 'earning'." Time and again she has shown him "that all mastery of personal success lies in focusing all one's power at all times on one particular point, the most important one."

Gustav had promoted the Alberto Giacometti Foundation when it was established at the Kunsthaus Zurich in 1965. He is a member of the Zürcher Kunstfreunde museum association, employs his contacts for the benefit of the Kunsthaus, and here too contributes a legacy for his mother. On her 80th birthday, he donates Chagall's *La fenêtre sur l'île de Bréhat* to the museum. This, however, only marks the beginning of a long-lasting initiative for the artist. Gustav becomes the driving force behind the expansion of Zurich's inventory of Chagall paintings, which will be made public in a specially conceived hall on 17 November 1973, comprehensively representing the artist's oeuvre.

Joan Miró at work on the mural at Joan Gardy Artigas' ceramic studio in Spain in 1971.

Natural spectacle, Day of Creation or war scene? Orientation may be interchangeable in the many-layered picture language of Joan Miró's *Oiseaux qui s'envolent*. The ceramic mural is now situated in the inner courtyard of Kunsthaus Zurich.

1972 At Gustav's suggestion, the Zürcher Kunstfreunde commissioned a ceramic mural by Joan Miró. *Oiseaux qui s'envolent* is presented to the public at the opening of the exhibition *Joan Miró, das plastische Werk* at the beginning of June.

1974 Since 1948, Abraham AG has been renting premises at the inner-city address of Claridenhof. In 1974, the company moves its 150 staff into a newly constructed building at Zollikerstrasse 226/228. Since the departure of Ludwig Abraham in 1968, Gustav has been the sole owner of the company and an influential figure in the international market for decorative fabrics.

"My links with art gave me the type of security that is crucial to my profession." Although the collector Gustav differentiates decidedly between artistic authorship and aesthetic challenges in fabric design, art informs his creative processes. "Art for me is part of my work, is inspiring my work." And soon enough, art works are entering the new business premises.

"Quality + cachet + audience" is how the newspaper *St. Galler Tagblatt* defines Kronenhalle's recipe for success the following year. With warm cuisine until late at night, Chagall's gladioli as a backdrop to your meal, reliable staff, "and at the next table, the actor couple Helmut Lohner and Karin Baal."

To this day, there is never a shortage of flower displays in the brasserie. Pictured in front of Marc Chagall's *Les glaïeuls* (1955–1956), Hulda shows herself to be a friend of all beautiful things. "I do not want to praise myself, but I am sure it is our personal contact with people that has turned the Kronenhalle into what it is today." Hulda Zumsteg watched over a staff who were often loyal to her and the Kronenhalle for decades.

1984 Almost concurrent with the restoration and expansion of the nearby Opera House, substantial conversion and renovation works at the Kronenhalle are completed in November. It has taken three years to follow through all necessary measures to upgrade the property to the new standards and regulations of a restaurant business. Yet the restaurant and bar were closed for only four months. Works on the additional basement and top floor go unnoticed by the guests. The plan behind all the efforts was to maintain the traditional style of the restaurant whilst equipping it with the latest technology. It was also thanks to the acquisition of extra premises for kitchen and service that business volume increased by 72%.

Hulda Zumsteg does not live to see the reopening. She dies on 14 July at the age of 94. Zurich's press is awash with obituaries. Hulda was synonymous with the Kronenhalle, herself an institution. From humble origins, she had worked her way up from maid to waitress and – at Gottlieb's side – become an entrepreneur with overall responsibility for the Kronenhalle. At the age of 65, she started to grant herself one day of rest a week, but even at 85 she would be the last to leave the restaurant well after midnight. *"Votre vie, droite et exemplaire, a suscité l'admiration et le respect de tous,"* wrote fashion designer Hubert de Givenchy on her 90th birthday. Since 1973, Hulda had commissioned the florist Maria Binder to decorate the brasserie regularly with opulent bouquets. Now Sihlfeld cemetery in Zurich is turned into a sea of flowers in her honour.

From 1975, mother and son shared the management of the restaurant and bar. He paid attention to this 'fateful' relation, as he often called it, in the best knowledge and conscience, before and beyond her death.

Yves Saint-Laurent and Gustav Zumsteg inspired each other mutually. The long-standing collaboration and friendship was expressed in the exhibition at the Museum of Modern Art, for which Zumsteg took over patronage. And it survived a period when the luxury market was under pressure and even the most renowned of all Parisian fashion designers had to curtail orders at Abraham AG.

1985 Gustav establishes the Hulda and Gustav Zumsteg Foundation, endowed with 50,000 francs. The foundation, amongst other purposes, supports the collection activity of the Kunsthaus Zurich in the area of contemporary art, and promotes young Swiss artists, thus signalling continuing support for Zurich's public art collection, to which Hulda has been contributing funds for the acquisition of innovative Swiss art for many years. The sole heir to the gastronomic and societal gem that is the Kronenhalle decides that upon his death all shares of the Restaurant Kronenhalle AG will go to the foundation.

1986 In August, Yves Saint-Laurent celebrates 25 years of collaboration with Abraham AG and Gustav Zumsteg at the Kronenhalle. Abraham had designed numerous creations exclusively for the Paris couturier. "His fabrics are half my fashion," reports the fashion star. "Collaborating with him comes close to a miracle, a permanent affinity between materials and colours," adds Gustav, who had supported *Yves Saint-Laurent – 25 Years of Design,* the 1983 retrospective at New York's Metropolitan Museum of Art, the Met's first exhibition about a living fashion designer.

In 1986, the German magazine *Stern* presents Gustav Zumsteg as "Zurich's fabric magician" and portrays him surrounded by art in his apartment at Rämistrasse 4. Since 2005, the three still lifes by Henri Matisse, Georges Braque and Chaïm Soutine (from top to bottom) can be found at Kunsthaus Zurich.

1988 During the celebrations for its 220th anniversary, the Zürcher Kunstgesellschaft reflects on the merits of Gustav the collector: "Not infrequently, Gustav Zumsteg has donated an important work to the Kunsthaus, and by his good example animated others initially in doubt to do the same." As a person he always acted with restraint and avoided the limelight, even when a promised legacy of seven works of Classic Modernism would have made a complete exhibition. Exceptional masterpieces that will enter the public collection on Gustav's death in 2005 include still lifes by Henri Matisse, Chaïm Soutine and Georges Braque.

In 1957, Joan Miró's *La table (Nature morte au lapin)* (1920) and Picasso's *Tête de femme* (1906), were still hanging in the Kronenhalle's dining room and brasserie, respectively. In 1995 Gustav Zumsteg sold both to cushion the crashing performance of Abraham AG.

1995 In June, four major works from Gustav's collection are auctioned at Christie's London: *La table (Nature morte au lapin)* by Joan Miró, *Tête de femme* by Picasso, Chagall's *Les Glaïeuls* and *La table de cuisine* by Georges Braque. The proceeds go to the Gustav and Hulda Zumsteg Foundation. The sale of such prestigious works evokes rumours about the declining business of Abraham AG. The man who "cast a spell on stars" and was once portrayed as "dancer on a silk thread" faces accusations of having run his business too much on artistic principles, and thereby neglecting the increasingly complex conditions of the textile and fashion market. No longer the sole owner since the 1980s, Gustav had allocated private funds and granted loans to the business against his adviser's opinion.

2002 In November 2002, Abraham AG has to declare bankruptcy and is liquidated. Gustav fears for his legacy. He privately buys the company archive out of the bankruptcy assets. He transfers the parts of the sample books and designs he considers museum-worthy to the Hulda and Gustav Zumsteg Foundation, which will donate the inheritance, together with a comprehensive collection of press coverage, to the National Museum Zurich in 2007.

Gustav Zumsteg had to witness how industrially produced, machine-washable clothes were taking over the market from exclusive fabrics and high-level designs. Yet even when he saw his dream of elegance and finesse topple, the Kronenhalle would lose none of its assured style, its art to continue to thrill guests and turn each meal into a feast. The precise documentation of a longstanding hanging plan is testimony to this indomitable desire for beauty.

2005 Gustav Zumsteg dies in Zurich on 17 June 2005, at the age of almost 90. In his will, he declares that all paintings and drawings owned by him privately are to be publicly auctioned. Part of the return is allocated to the pension fund benefitting the staff of the Kronenhalle. During the sale of books and lithographs from his private library, testimonies of friendships and mutual appreciation between patron and artists also find new owners.

The most important legacy left behind by Hulda and Gustav Zumsteg was and remains the Kronenhalle. The mother had received her son's promise that he would continue the business after her death. He took on the Kronenhalle as his "second life's task". Select works from his collection, too, reinforced the restaurant's position.

In his will, Gustav declared that the works in the restaurant and the bar should remain there. His *accrochage* in the possession of the Hulda and Gustav Zumsteg Foundation documents the original hanging plan. What the art lover can no longer move himself will remain in place in perpetuity.

34

Reto Finger
There'd be so much more...

Hulda I'll have another glass / one last one / the open one / the Vaud / Ella, d'you hear me? / d'you hear me, Ella? / don't open a new one, but if there's one already open / it's good / better than last year's / don't you think this one's better, Ella? / what's that look for? / you'd think we'd had three days of rain / this Vaud's a good one, you can look at me how you like / it's not just me that thinks so / there are people in here that never ordered fish / but now they do, just to stay with this Vaud / and if people start ordering perch in beer batter just to stay on the Vaud, then it must be a good one / right, Ella? / it's true, we get through far more perch now we have this Vaud on the menu / get us two glasses, the way he's looking at me, get us two / what, what's that look for, what?

Gustav Could I imagine that? / could I? / imagine it "starting now"? / now, here, Gottlieb / me, with her / not that I, Gottlieb / God knows, no / I'm happy to stop sharing / and stop missing out / we never shared / well, he didn't anyway / divvied up, maybe / and now just like that? / just like that, and "starting now"? / even though it's almost closing time, so there's no time to think about it, either / and there'd be so much more we should / there'd be so much more we first should / "my stuff", she said, they'll come and pick up "my stuff" / there'd be space enough upstairs for "my stuff" / and if I had "this or that" for Abraham & Brauchbar / "this or that" she said / those were her words / as if running a silk factory was just as much work as setting a place for starters / and then that "starting now" / if it's not about her guests she's not interested / never has been / wasn't at the Schöchli-Schmiede, wasn't at the Mühle and isn't at the Kronenhalle / first the guests, then Gottlieb, then the guests again / and now I'm supposed to, "starting now" / and with a glass of this wine / so there's no time left to even think about it...

Hulda Empty, how? / that can't be / we always have a bottle chilled / ask in the kitchen, there's always one chilled / what do you mean, it's already been used? / why aren't I told if the Vaud reserve gets used? / all right, all right, that's always the way / give my best guests the whole bottle and it's gone / probably a good thing / must be a good thing / if you sit around with friends, the bottle's just gone...

Gustav Once a month / once a month, for just a few hours / when the last lunch guests have gone and the first after-workers are yet to arrive / once a month / all through my schooldays / and now she's suddenly talking to me / like a waterfall / sometimes I helped to mop the floor / me and my mop / that smell of soft soap / I still know the smell / once a month, half an hour along the Limmat if I hurried / half an hour along the Limmat, to kneel at a bucket and get that smell in my nose / that smell of her and the mop's soft soap...

Hulda Ella, fetch a new one from the cellar / we never do that / we never open a new one for ourselves / but we're celebrating today / even if Gustav's been a little quiet / we still have something to celebrate / because he didn't say "no" / he may not have said much / but no "no" is a "yes" / so fetch a new bottle and an extra glass and sit here with us / maybe he'll warm up a bit if you sit here, too, and get to know your new boss / maybe it'll warm him up...

Gustav We need a bar / if you want me to help here, we need a bar for drinking in / a bar they can come to day or night, when the loneliness gets too much / a bar for people with no family / a bar for people with too much family / for people that live in their studio by day but need to spend the evenings with someone they can talk to...

Hulda Come in, then, if you want / you're here all on your own / you've come all this way alone / just for me, all this way for me / we'll be seeing each other next month again / you needn't have come all this way just for me / here in the Mühle there's nothing to see, just worn old floorboards / what are you crying for? / you've come all this way through all that rain / just to start crying at the door again? / what's wrong with you, starting crying again as soon as you set eyes on me? / is it my looks that bring you to tears? / my apron and bucket that bring you to tears? / well come in, then, if you have to / I don't have much time, though, only half an hour or so, to mop this whole floor / see that place there, that place by the bar? / from there to the regulars' / that's all mine / I've been leaving my mark on the boards in between for a good two years now / but that's about all there is to see around here / I told you there's nothing to see round here / the Schöchli-Schmiede, that was different / a lot to see round there / like a boy your age / a boy your age who had six fingers / what a show he was, that boy your age / nobody'd

notice at first / what's a boy doing here, is all they thought / and so late up, too? / but then he'd take a glass in his hand, and pull his last finger – his sixth – away from the glass, with an elegance you'd see in Paris, maybe, but not in the Schöchli-Schmiede / and then you saw it / that sixth finger / so scary the guests would spill their beer and order another / or that Dutchwoman / they'd stand all the way to Niederdorfstrasse to get a look at her / even Gottlieb came to see / even though he'd never been in the Schöchli-Schmiede before / and he stayed to the end / but not for the Dutchie / oh, those were times, in the Schöchli-Schmiede / but here, here in the Mühle, it's not just drinking but eating, too / and that's why there's so much to do / nevertheless / I always say nevertheless once a month / so many other kids have it different right now / so many other kids have it different / if you had two heads or three arms, now / like the boy with six fingers / then every evening we could / what, what is it? / no, I didn't / for that? / you really don't need to / you didn't come all this way / come in for a bit, then / but then I do need to get going again / I'll see you again soon / next month I'll see you / or the following month for sure...

Gustav You can't compare it, a bar like this, not a bar like this, you can't compare it with a Niederdorf bar / with a Boulevard Saint-Germain bar, maybe / like the Café de Flore or the Deux Magots / we have to go there / you have to come to Paris and see / if you don't know the difference between the Café de Flore and a Niederdorf bar / or ask Alberto / or Giovanni / they know the difference...

Hulda What was he up to? / what was Giovanni up to when he gave me the picture? / like Gustav and you, he said / but the people in the picture are nothing like us / they're looking for winter wheat sprouts, he said / stark naked, looking for winter wheat sprouts / it does make you wonder what kind of farmers he knew / you're as attentive, he said, as they are with the wheat / and sometimes he felt we'd sown good sprouts, too / he said that / Giovanni said that...

Gustav In Paris they spend the whole night talking and in the Niederdorf they'd rather not talk at all / that's the difference, Giovanni said / and he said he'd help us make a bar like that / a bar to see friends at nighttime, too...

Hulda Here's fifty *rappen*, my father said to me / fifty *rappen* for your fourteenth birthday / and shoved me on a train / a train that cost ten *rappen* / a train that went to Zurich / a place where I didn't know a soul / I got in, into the train, in third class / looked for a free bench, or at least a free seat / found a bench, or half a bench at least / held the two twenties that I still had from the fifty really tight in my hand / on the train / on the train to Zurich / and I thought / Hulda, I thought / Hulda, you're so poor and so unsure / don't ever be like this again / never again your whole life long / and that's why I've always made sure that I never again feel so unsure / and that's why I went to the Mühle without you, because without the Mühle I'd have been unsure / and that's why you were on your own with Mademoiselle Vuillemin for those few years / and that's why you speak French, which is no bad thing / that's something too, your French…

Gustav There'd be so much more we should talk about / there'd really be so much more / his first name, for instance / my father's first name / or why the Mühle always had so many empty rooms / but sometimes talking's no good, either / even if there'd have been so much more / talking still doesn't help / not with everyone / it's good we have our bar, though / a bar for talking / five minutes more / five minutes more till closing time / and then another quarter of an hour till the ones who keep the order quieten down, too / and then up / up to her bed / to have a quick chat / because she's got used, over the years, to a few words with friends before she goes to sleep…

Hulda There's one thing you must promise me, now I can't stay down there to the end every night / one thing you must promise / to keep things as they should be / Ella always says / Ella's always said / you only leave here if you wed or die / Ella always says / and you're not going to marry, are you? / so you must promise me to keep things as they should be / Ella's brought me a carafe of wine up here to my bed / so have a glass of this Vaud that really is so good / and let's leave things as they were / and you promise me / to keep them as they should be, too.

37

Reto Finger (*1972, Bern), read law in Zurich and Amsterdam, and first worked at Zurich District Court, then at the Federal Administrative Court in St. Gallen. He wrote his first play *Schwimmen wie Hunde* (2005) under the auspices of the *Dramenprozessor* grant programme at the Theater Winkelwiese. His *Kaltes Land* (2005) received the renowned Kleist Promotional Award for Young Dramatists. He was in-house author at the Nationaltheater Mannheim and the Schauspielhaus Bochum, and was subsequently commissioned to write plays for the Staatstheater Stuttgart (*Fernwärme,* 2006), the Schauspielhaus Zürich (*Vorstellungen und Instinkte,* 2009) and the Theater Basel (*Farinet ou la fausse monnaie,* 2016, based on the novel by C.F. Ramuz). He lives with his family in Augsburg.

[→ 112, 96, 101, 115, 94]

[→ 110, 98, 99]

[→ 89, 112]

[→ 91]
52

54

58

Ariane Koch
En voiture

Ariane Koch (*1988, Basel) studied visual arts, philosophy and drama in Basel and Bern. She writes and devises theatre, performance and prose texts, sometimes in collaboration with Sarina Scheidegger or the theatre company GKW. She has exhibited and performed around Switzerland and in places as diverse as Berlin, Alexandria and Krasnoyarsk. She is currently working on her first novel *Die Aufdrängung*.

63

70 [→ 114, 98]

[→93]

[→102]

[→ 110, 97]

78

Michael Fehr
**it's the last day of summer
this year**

it's the last day of summer this year

the weather is deep blue and deep gold

and in the lush green meadows stands a wooden house that summer has burnt wonderfully black and around it stand a number of lush green apple trees

out of the house comes a woman with a folded white tablecloth to cover a black-burnt wooden table in the green meadow in front of the house following the woman a man exits the house with a wooden tray laden heavy with white plates and bowls

soon the table is set there is golden bread and golden butter and golden honey

across the meadows a woman and a man with the intimacy of a married couple and another single man come towards the black-burnt house amid the green they are the guests

soon everyone is sitting around the beautiful table

but the hostess gets up again "i can't tell you how delighted i am to have you here once again help yourselves take what you like there's enough of everything shortly i'll bring golden milky coffee too" the guest who has come alone "but please stay seated for now let us eat a slice of bread with honey together it'll still be early enough for coffee afterwards" everyone agrees with him the hostess sits down

everybody takes bread and butter and honey everyone bites into the tasty thickly spread sticky slices of bread

the woman and the man who came to visit together "this tastes incredibly good to me" "it also tastes incredibly good to me" the hostess "i'm delighted about that"

the woman "there are apples lying in the meadow i'll eat one" the hostess "why not take one from the tree over here you don't have to eat apples from the ground at our house" the woman "no i enjoy them i love ripe and overripe apples"

the woman searches the meadow until she finds an apple that particularly appeals to her she returns to the table bites into the apple "delicious"

"and look how lush the meadows are i'm going to tug out a tuft of grass and eat it" no sooner said than done the woman bends down plucks a tuft and bites into it "delicious"

embarrassed the hostess laughs "no are you sure" the man who is visiting along with the woman "let me try some too" the man tugs a tuft and bites into it a glow comes over his face "it tastes incredibly good to me"

the hostess no longer embarrassed but encouraged "let me try some too" she tugs a tuft and stuffs all of it into her mouth her face brightens

the host "and i'll break some twigs off an apple tree and eat them" he jumps up from the table leaps to the nearest apple tree breaks off twigs and bites into them his delight is clear to see

the hostess "with this knife i'll now scrape myself a piece of bark off the tree and spread butter and honey on it and eat it" does everything as she has said then lays her plate onto the piece of

bark that is thickly spread with butter and honey bites into everything at once "delicious"

the woman "i want to eat my plate too and with it i'll eat this bowl"

the man "and i'll eat the tablecloth" he pulls on the tablecloth so that everything still standing on it is sent flying into the meadow bites into a corner of the tablecloth and stuffs it gently and pleasurably piece by piece into his mouth

the guest who came alone makes a surprised yet badly disconcerted face he gets up and stops in the meadow a few steps away from the group all he can do is stare at the commotion

the man "i'll plough my face through the meadow and devour grass and soil and gravel so it splatters and crunches" his head buried deep the man crawls through the meadow

the woman looking at his bottom "you'd better be careful that i don't bite your bottom" the man leaps up startled "are you crazy you can't bite me i am your lawful wedded spouse" the woman "calm down that's just a joke i'll actually go into the house pull a black beam out from under the roof drag it into the bright light and devour it"

the hostess "and i'll thickly smear my hands with the butter that's lying here in the meadow climb onto the roof and devour some wonderfully black-burnt tiles while i lick butter from my fingers"

the host "and i'll dash into the house and devour the percolator along with the coffee and wash it all down with a gulp of milk if i recall correctly we even have two percolators if i enjoy the first one i'll devour the second one too"

the guest who came alone "this really cannot be happening" the hostess "no false modesty now be our guest dig in"

as the guest who came alone meets the hostess's now demented gaze he cannot help himself but takes a leap backwards at his fastest pace he walks away through the green meadows some distance away he starts running in fear he runs back the same way he had so peacefully confidently and joyfully walked earlier in the village close by which fortunately has a station he just manages to catch the next train home at home he turns on the radio TV and computer to see if the vile events have already been discovered by someone sensible

and sure enough the news reports that a hunter who had set out to get an idea of what one might shoot in the area in autumn this year had through his binoculars observed a group of people who had gone completely insane in the green summer meadows by a beautiful black house that the hunter had immediately alerted the police who upon arriving at the spot had agreed that an easy rescue was no longer possible and then with the assistance of the seasoned and courageous hunter had the crazed group shot from a safe distance

Michael Fehr (*1982, Bern) studied at the Swiss Literature Institute Biel and the Y Institute of Bern University of the Arts from 2007 to 2012. He has published the books *Kurz vor der Erlösung* (2013), *Simeliberg* (2015) and *Glanz und Schatten* (2017). He is the voice on Simon Ho's music album *Bruxelles* (2016). As a narrator, he works with the possibilities of repetition, reduction and articulation, often blurring the boundaries between text, reading, performance and song culture.

83

From Bonnard to Varlin
The collection at a glance

As long as the Kronenhalle exists as a restaurant and bar, the works are not to be moved from their designated places. This is stipulated in the patron's will, and guaranteed by the Hulda and Gustav Zumsteg Foundation in granting the works to the restaurant as permanent loans. This not only respects the collector's wish; it also means that every guest is entering a very personal chapter of art history. The backbone of the collection consists of French modernist painters, practically all of whom Gustav Zumsteg knew in person. Their striving to find poetry in reality, their devotion to pure observation, their sensual approach to form and colour, had fired the collector's enthusiasm. In Zurich, he added Swiss artists who often measured their figurative work against French role models. Later acquisitions also include pop artists.

Not all works lay claim to the same artistic status. Among the museum-quality paintings, there are souvenirs from artists who wanted to thank the collector or the hostess personally

with an original work. Collection highlights like Georges Braque, Marc Chagall and Joan Miró draw the eye when ordering the artists alphabetically. But an ABC also creates new idiosyncratic juxtapositions – it reveals varying artistic mentalities and bears testimony to the natural coexistence of personal respect and artistic appreciation. The following pages feature all fine artworks that can be seen in the publicly accessible spaces of the Kronenhalle, with the exception of photography and some lithographs. These are, however, listed in the graphic illustration of the hanging on pp. 118–125, and wherever possible the date of creation and the artist are listed against each exhibit.

"Ceci n'est pas un musée," commented André Malraux at the opening of the Fondation Maeght in Saint-Paul-de-Vence in 1964. The same holds true for the Kronenhalle. Nevertheless this book aims to provide the visitor with a reliable guide for artistic orientation around the house.

Pierre Alechinsky (*1927)
Composition, 1974
Ink and watercolour on paper,
26 × 19 cm

Cuno Amiet (1868–1961)
Portrait of James Joyce, 1939
Pastel and crayon on paper,
19 × 23 cm

Assia
*View from a window onto
landscape,* 1980
Watercolour on paper, 24 × 20 cm

Hans Berger (1882–1977)
House with trees (Les toits), undated
Oil on canvas, 35 × 47.5 cm

87

Joseph Beuys (1991–1986)
Untitled, undated
Pencil on paper, 23 × 23 cm

Max Billeter (1900–1980)
Potato harvest, undated
Charcoal on paper, 21.5 × 20 cm

Pierre Bonnard (1867–1947)
*View from the window
(Ferme à Vernon)*, 1932
Oil on canvas, 65 × 76 cm

Wizard of colour, chronicler of the city A wooden balustrade intersects the view from the window. The dark bar gradually adopts the yellow of the background on its left, either as if bleached by the sun or idiosyncratically altered by the painter. The balustrade is flat like the sky, the roof, the wall, the fence and the flower garden. As early as 1898, Bonnard had left behind any thought of spatial depth. The field in the foreground of his landscape lies parallel like a patterned ribbon spanning the meadow. Reminiscent of a photographic image, Bonnard's painting tests everything visible for its light and colour value, leaving many details hidden until inspected more closely. Is there a human figure in the courtyard? Is there a wheel turning behind the protruding wall?

In his Paris diary *Pariser Tagebuch,* Gotthard Jedlicka describes Bonnard's paintings as each being incredibly rich in secret colour associations. And this is certainly true of *Ferme à Vernon*. Like the weave of a carpet, the paintbrush seems to have kept all surfaces soft, and the colours appear to shine through both Bonnard's inward and outward views. Such a light-flooded painting seems ideal for evoking a lost Arcadia. Yet Bonnard was a man of the city too, tackling artistically topics of fast growth, early traffic, the increase in boulevards and cabarets. Between 1891 and 1947, more than 120 of his prints were circulating, among them book illustrations, theatre programmes, exhibition posters, all testament to an awareness of life hovering between unease and seduction.

Glamorous Paris is part of Bonnard's repertoire as much as his observations showing the rift between rich and poor in a single figure. It is, for example, with a rather awkward tilt to the right that *La petite blanchisseuse* compensates for the heavy weight of her washing basket. Her angled feet and tiny hands suggest her dark silhouette might be moving at a hasty, fearful pace. The print was released in an edition of 100 in the *Album des peintres-graveurs* by Ambroise Vollard.

The poster *La revue blanche* speaks of a very different social role. The cover of the literary magazine lures its readers with a woman whose fashionable attire might also promise erotic adventure.

Pierre Bonnard
Landscape, 1898
Oil on wood, 37.5 × 46 cm

Pierre Bonnard
La petite blanchisseuse, 1896
Colour lithograph, 29.5 × 20 cm

Pierre Bonnard
La revue blanche, 1894
Poster (printed by Edward Ancourt, Paris), 77.5 × 59 cm

Pierre Bonnard
Nude, 1898
Ink on paper, 19 × 14 cm

Georges Braque (1862–1963)
La plaine II (1955–56)
Oil on canvas, 33 × 55 cm

Terra pictura Landscape is an event. Where the sky meets earth or water, we see a horizon. Below, the painter throws hues of brown or beige onto the autumnal field – colours applied restlessly as if by the wind. Above, he unites white and cobalt blue in a lively backdrop framed by a dark rim that keeps alive the memory of the night.

Georges Braque did not avoid any object or subject when researching the structure of painting. In his Cubist phase he maintained a professional exchange with Picasso. Both painters subverted the conventions of looking and the idealistic general view of their objects, presenting them at various angles all at once. Braque lifted bowls, bottles, fruit and musical instruments out of the central perspective, renounced their natural colours and thus liberated each tactile object from the rules of early painting. He was to remain a master of simplification. His vocabulary of signs, outlines and allusions would earn the painter, graphic designer and sculptor major commissions for ceiling and window paintings.

"I'm seeking to ally with nature, not to mimic it," the artist notes in his records. If you want to create something, he adds, you need to leave its image behind. "It is not enough to render visible what one is painting, one needs to offer it to the touch." He explains that unlike the Impressionists, who focused on depicting nature as an expression of light, "sprinkling small pieces of sky everywhere", he himself was dedicated to tackling space. So he unravels the field of view, and at the same time delivers proof of both the two-dimensional canvas and the secrets of air and expanse. He pushes rowing boats across the beach, draws a bird's flight into the sea, lets smoke rise above a sail in the far distance. In a pine-green sky or a white beach, he questions our understanding of nature.

Georges Braque
Vase, undated
Etching, 33.5 × 17 cm,
dedicated

Georges Braque
Grande tête, undated
Copperplate engraving
(drypoint), 45 × 37 cm

Georges Braque
Gros nuages, 1952
Oil on canvas, 51 × 66 cm

Marc Chagall (1887–1985)
The clock as violinist, 1970
Mixed media on paper,
25 × 33 cm, dedicated

Enamoured with the world A grandfather clock is playing the violin. The village gathers beneath a crescent moon. A blue house regards a woman who seems suspended by a dream upside down. The encounters are full of secrets. Marc Chagall carried forward the naive gestures of folk art, scenes of bucolic customs and Jewish traditional figures far into the twentieth century. Real political breaches and the double shocks of revolution and war anchor his art in an area of tension between East and West. His niece Meret Meyer concludes: "One seems to detect a dialogue: the inner journeys and the outer voyages lived over the years look at each other, smile at each other, await and surprise and lose each other just to reunite again in a light, bright and flourishing sky." She adds that he travelled in Holland, Spain, Italy, Egypt, Palestine and the South of France, and each time gratefully got to know a new light and new mentalities. The summary of all the seas and all the sunsets he witnessed compete in *Le coucher du soleil,* echoing the blue that also illuminates Chagall's stained-glass paintings in synagogues, churches and institutions like the UN headquarters. The painting leads you almost to believe that figures are emerging from the canvas to perform an inner world. Perhaps they are there once the last ray of light has disappeared and the lonely figure above the city has merged with the sky.

Chagall's gift to the twentieth century was to reconcile the most progressive paintings from his early Paris years with the charm of narrative. His capacity to preserve and artistically express great awe in spite of all the surrounding upheavals earned him important public commissions like the ceiling painting in the Opéra Garnier in Paris (1964) and the windows in the Fraumünster church in Zurich (1970). In the catalogue for the 1967 Kunsthaus Zurich exhibition, René Wehrli calls the painter "a dreamer enamoured with the world". Chagall unsurprisingly cultivated a lively relationship with the stage, and famously designed the costumes and set for a performance of *The Magic Flute* in New York. The Kronenhalle, like many other institutions, proudly shares the artist's trust in culture, be it on the walls, on the menu or in memory.

Marc Chagall
Le coucher du soleil, 1974
Oil on canvas, 64 × 80 cm

93

Marc Chagall
Harlequin, undated
Ink and watercolour on paper,
47 × 23 cm, dedicated

Marc Chagall
Bouquet, undated
Oil on canvas, 35 × 27 cm

Marc Chagall
Bouquet with lovers, undated
Watercolour and crayon on paper,
37.5 × 28 cm, dedicated

Eduardo Chillida (1924–2002)
Hand, undated
Felt-tip pen on paper,
17 × 13.5 cm, dedicated 1970

Eduardo Chillida
Hand, undated
Felt-tip pen on paper,
13.5 × 17 cm, dedicated

Adolf Dietrich (1877–1957)
Two squirrels, 1902
Pencil on paper, 45.5 × 28.5 cm

94

Theo van Doesburg (1883–1931)
and **Kurt Schwitters** (1887–1948)
Small Dada Soirée, 1923
Lithograph in red and black
on paper, 29.7 × 29.5 cm

Friedrich Dürrenmatt (1921–1990)
Minotaur with a glass, 1988
Lithograph, 25 × 24 cm

James Ensor (1860–1949)
Pot plant, undated
Charcoal on paper, 22 × 17 cm

Lyonel Feininger (1871–1956)
Manhattan, 1940
Charcoal on paper, 28.5 × 20 cm

Between worlds "In Germany it's all over for us, and here nothing has started yet," Lyonel Feininger wrote to the painter and gallery owner Galka Scheyer from New York. He would have to forget that he was a successful artist in Germany. In 1937, Feininger had left behind his oeuvre, which had been ostracised by the Nazis. Yet he did take with him what the images of Old World cities and cathedrals had taught him: that everything seeks a relation with the sky, that architecture is made of light and shadows and that lines and surfaces are meant to be kept mobile.

Manhattan might be proof that Lyonel Feininger was not a painter at his core – that it was not so much the colours of a cityscape that interested him, but rather the question of how its architecture relates to the sun. Crystalline in its structure, his small city vision, particularly its foreground, is left to the blur of charcoal dust. Is it the Cities Service Building glittering brightly in the centre? Its tip moves it to the upper rim of the paper as was the case with Feininger's earlier icon of new frontiers pointing toward the sky. On the establishment of the Bauhaus Building in Weimar, the young caricaturist and illustrator had donated a woodcut, cleverly underscoring the broad belief in this "building of the future". Flanked by stars, the Gothic ideal of the modern age emerges from a glistering sea of rays. The building as a work of art also symbolised the revolutionary curriculum's promise to bring together architecture, art and craft in one future.

Any euphoria that the fast growth of New York's business and finance centre could elicit is carefully blurred in *Manhattan*'s chiaroscuro shades. Without celebrating the city, the image's view from the deep street up to the skyscrapers leaves a monumental impression. An extensive show at the Museum of Modern Art in 1944 would cement Feininger's reputation in the United States. The artist, the American son of German parents, who had left New York for Europe at the age of 16 in order to study, remained at home between the two worlds – and established himself internationally as a leading exponent of Expressionism.

Augusto Giacometti (1877–1947)
Birdcage, undated
Oil on canvas, 44 × 53 cm

Augusto Giacometti
Window, 1928
Pastel on paper, 30.5 × 17 cm

Freedom of colour "I always felt there must be life in colour per se, independent of any object." All his life, Augusto Giacometti worked on "deriving from nature its laws of colour". As early as summer 1898, he was painting butterflies in Paris's Jardin des Plantes, and much later parrots in the zoo of Marseille. Why should their feathers be yellow and blue? The painter thus learns that no object exists in isolation, that the green of the jungle is enlivened by the different-coloured plumage. This bird in its cage is surrounded by the shadows of dark green branches. The cage is laid out so delicately across the canvas that its bars seem to give rhythm to the painting rather than constrain it. From afar at least, the creature appears to be framed by a thin birch forest or hidden by glass pearls. The painting has dabbed the bird into life without capturing it completely.

It is no surprise that Giacometti took a close look when he stood in front of Cologne Cathedral's glass windows in 1928. Someone who sought to challenge God with self-irony as a painter could not find a better view. Light is the topic of his art, which overcomes exact replication in favour of an explosion of colour. The window's colour-flooded light seems to erect, order and stabilise all the figures with radiance. It is difficult to make out individual scenes, but the point is much less a narrative than the stupendous luminosity that is also present in Giacometti's small-scale, soft-textured pastel on paper.

By the time of the Cologne visit, the grand colourist had built up his reputation via public commissions. His frescoes in the entrance hall of Zurich's administrative police headquarters had been completed three years earlier. The churches in Küblis (1921) and Winterthur (1923) also commissioned his strict symbolism and opulent colour work for the design of their new windows. By 1929, another would be in preparation for the Protestant church of Frauenfeld. Giacometti never tired of learning from historical role models. Respecting medieval aesthetics, and through his own artistic language, he produced designs for the contemporary world.

Diego Giacometti (1902–1985)
Two lamps, 5 arms
Bronze, H 75 cm

Diego Giacometti
Two pendant lamps on chains
Bronze, H (without chain) 31 cm

Diego Giacometti
Two lamps with owls
Bronze, H 62 cm

Soft claws Knowing that Diego Giacometti drew his inspiration from Paris, one can readily see it in his work. In the centre of Place de Fürstenberg, for example, you'll observe a five-armed candelabra lamppost competing with the branches of low surrounding trees. Whereas in Paris the lights are encased in Cubist frames, in the Kronenhalle bar Giacometti employs luminous alabaster balls to let multiple full moons rise.

Like endless spines, two metal chains lower the weight of the pendant lamps link by link to the lower third of the bar's floor-to-ceiling windows. One can sense Giacometti's love for demonic allusions and fantastical punchlines. The pendant lamps seem to be encased in an archaic dance of bones, nails and soft claws, and at the base of his table lamp a small, discreet owl is watching the guests.

Diego Giacometti's production of lamps, furniture and ornamental objects has its origin in a service he rendered for his brother Alberto's art. It was Diego who constructed the delicate metal frames that are tailor-made structures for his brother's busts and heads. And even when he stepped out of Alberto's shadow, he predominantly worked on commissions. In the cafe of the Fondation Maeght (1964), in the Musée National Message Biblique Marc Chagall in Nice (1973), and in the Musée Picasso in Paris (1985), his accessories remain on the sidelines of the main attractions, from where a small bird, a cat or geometric foliage build playful little bridges to another world.

Diego Giacometti
Nine bistro tables
Bronze, red-white marble, H 67 cm

Giovanni Giacometti
Sea of fog, undated
Crayon on paper, 17 × 25 cm

Giovanni Giacometti
Fanciulli nel lago (Alberto and Diego in Lake Sils), 1916
Coloured woodcut, 20 × 20.5 cm

Giovanni Giacometti
Toeletta della sera (Portrait of Annetta Giacometti), 1911
Woodcut, 25 × 20.2 cm

Giovanni Giacometti
La notte I, c.1913
(Posthumous edition 1964),
Woodcut, 21.5 × 24.5 cm

Giovanni Giacometti (1868–1933)
Mare di nebbia, 1915
Oil on canvas, 76 × 100 cm

Colour in light The Val Bregaglia remains the Val Bregaglia, but the light is distributed differently across the sky and mountains since Giovanni Giacometti captured his homeland with the palette of his time. Born in Stampa in 1868, the painter researched the contrasts and luminosity of colour in Munich, Paris and finally with Giovanni Segantini in Maloja. These explorations could not remain without consequence for our views of mountains and valleys. Giacometti's peaks no longer serve as backdrop to idyllic bucolic scenes. They also lose their eerie and heroic nature that, only a few decades ago, had hikers trembling from acute danger and saw cartographers dwarfed to small figurines on the sidelines. Giacometti's expedition is exclusively dedicated to the phenomenon of 'colour in light'. He thus adds yellow flames to the sky and a rose-coloured hue to the fog covering the valley below. Shadows are blue, a sun-drenched forest clothes the mountain flank on the right with a solid green border, and the top of a pine tree reassures us that, despite all distance, there is proximity and stable ground at our feet.

Whether it is his coloured crayon chiselling the expanse of a mountain landscape out of white paper or his burin etching the image of his young wife into wood, Giacometti's palette between light and dark always bears the touch of a caress. In the village, the night is not threatening. Annetta loosens the plait from the hair crown pinned to her head and lets it glide across a shoulder into her slender hands. The brief moment when his sons Alberto and Diego crouch over the glaring waves of Lake Sils, too, is suffused with affection. *Boys of the Sun* is how Giacometti had titled an earlier sheet. In his expressive, nervous line summarising the youthful bodies, the topography and the light of the Engadine and Val Bregaglia are paramount.

It was not only Giovanni Giacometti who turned the southern mountain valley into a famous name in Swiss modernism. His second cousin Augusto Giacometti, too, had already ventured from Stampa to Zurich and on to Paris in order to study the latest tendencies in art. Giovanni's son Alberto would return every year to his father's studio and an intimate dialogue with his mother, even as inter-war Paris led him to take very new roads. In the early 1930s, Diego joined his brother for joint work trips, and third sibling Bruno was starting out as an architect in Zurich. So it is hardly surprising that the Giacomettis should open a window onto the mountains at Kronenhalle too.

Max Gubler
Self-portrait at the easel, seated,
Unterengstringen 1944
Oil on paper, 60 × 50 cm

Julio Gonzalez (1876–1942)
Head, 1934–1936
Bronze, H 32 cm

Julio Gonzalez
Deux bouteilles, 1936
Enamel paint on metal, 16 × 13 cm

Max Gubler (1898–1973)
Night, Unterengstringen, c. 1952
Oil on canvas, 50 × 61 cm

Floating borders It seems easy to capture the night. Bright dots circle the face of the moon and mobile reflections on the water surface are just there, self-evident, without detour or correction. The figure about to leave the canvas to the left has soaked up so much darkness that it nearly melts into the surroundings. The place of the scene is not discernible. But the air is full of a cool hue that can only stem from water. The lake is any lake, where there are boats and fishermen perhaps, and where the stars can still compete with electric light.

Born in Zurich, Max Gubler had learned various styles in Berlin and Paris and also lived and worked through an abstract period. His painting aims to transcend traditions whilst still following the academic canon of portraiture, still life, landscape and interiors. Although hailed by critics as the most important Swiss painter since Hodler, his comprehensive oeuvre must have also evoked bewilderment at a time when abstract artists were more trusted and figurative works accused of being trapped in tradition. By the end of the 1950s, Gubler would be at the peak of his fame yet in an existential crisis. "I am the fallen Icarus," he would say. His wife Maria and his friends, among them the art historian Gotthard Jedlicka, record his threatening mental states in psychiatric clinics as well as new artistic attempts and sporadic sojourns at the studio.

Gubler's wish to see his late, far more expressive works in an exhibition was granted neither by his wife nor by his long-term mentor. His late oeuvre, the 'painting in crisis', was kept under seal and only viewable again from 2014.

His portrait in the Kronenhalle recalls his rather risk-averse side. Above the left temple, a grey shadow runs down into his collar. The sleeve of his shirt lies heavily in the painting before it runs seamlessly into the primed canvas. The hand that remains hidden whilst the painter regards himself almost renders him a prisoner of his own making.

Ferdinand Hodler (1853–1918)
Cherry trees, c.1901
Oil on canvas, 41 × 32.5 cm

Hodler's garden You would need to be able to fly to get close to that small row of trees. There is no path to the subjects of Hodler's painting. The grass, which initially reveals tall blades and white blossoms, becomes a homogenous carpet as the eye glides from the foreground to the centre of the image. The meadow turns into a pedestal for five trees, whose slender trunks hold the crowns just above the horizon. Is this serene grouping by Hodler a result of mere observation? Or is the painter already preparing for his later landscapes, which he will artificially superelevate with symmetries and mirroring?

Since the mid-1890s, the painter had been looking unhindered into the depths, "searching and approaching," as the art historian Gottfried Boehm described it. Initially almost "below the threshold of attention", he enforces flatness, introduces rhythms, and orders the space according to rules by which view and perspective, recognition and slight alienation gently seek their balance. The trees stand very still in their row; the wind, which has dug dark shadows into the crowns and nearly ripped apart their branches, particularly the first tree on the very left, has abated. It has left the two compact crowns in the middle untouched. Slowly, the artist's will to penetrate to the very heart of things is germinating in this tender portrait of a group of trees.

"The artist's calling, if one may speak of such, lies in expressing what is eternal in nature, namely its beauty, and for that its essential beauty," wrote Hodler. He wants to show an "enlarged, simplified nature", one "free of all the details that mean nothing". Hodler's commitment to a form of painting that eliminates anything marginal or incidental from its surfaces elevates each section of a landscape to a model of the exceptional. The human being leaves the picture and is thus invited to observe more intensely. Each fruit tree may be a tree of knowledge.

Max Hunziker (1901–1976)
Dialogue ou soliloque, undated
Hand etching on paper, 18 × 13.5 cm

Wassily Kandinsky (1866–1944)
Two girls, 1907
Linocut, 21.2 × 12.7 cm

103

Before *Der Blaue Reiter* They could be saints. The head coverings of the two figures in the painting are reminiscent of luminous haloes; the elongated neck and the play of the hands speak of grace, affection and perhaps awe. Within the soft contours of the linocut's colour fields, the mysterious pair remains part of the landscape. Small clouds rise, a birch tree tosses its last foliage – red, green, yellow – into the sky. Kandinsky's small sheet leads you into the fairy-tale world of his early works. The artist had settled in Paris for a year, where he would work on small Impressionistic landscapes, often working outside. In his references to folkloristic motives from an earlier Russia resides a subtle protest against the Tsarist Empire and the Russian élite eager to catch up with Western modern culture. Depicting a colourful country life grants Kandinsky space for memories as well as free artistic expression. At stake, however, are not only outdated ways of seeing. Together with other internationally connected artists, Kandinsky is aiming for a 'spiritual rebirth' of art. More than 100 years later, we know that the most innovative images of his generation are nourished not least by the expressive power of role models far away in time and place.

Johannes Itten (1888–1967)
Apples, 1930
Colour pencil on paper, 27 × 28 cm

Anna Keel (1940–2010)
The blue soda siphon (book cover design for Urs Widmer), 1992
Oil and charcoal on canvas, 35 × 27 cm

Anna Keel
Moritz Schumacher from Berlin with raised jacket collar, profile view, 1986
Pencil on paper, 19.5 × 16 cm

Reinhold Kündig (1888–1984)
Landscape, 1910
Oil on cardboard, 36 × 51 cm

Paul Klee (1879–1940)
Tightrope walker, 1923
Colour lithograph, 45 × 28 cm

To carry a line Paul Klee titillates the nerves without providing a hook or anchor. Is the figure stable? Will he fall? Are his footless legs attached to the rope? Is the performer even capable of movement? It is unclear what is keeping the structure together, but what is certain is that the lines and perspectives do not offer any solid ground. The balance is fragile even if the tightrope carrying the man is resting horizontally and he himself – looking back, stepping ahead – may be about to reach the dangling rope ladder.

Klee has been described as a mystic and a poet among the painters of his time. This could lead us to forget that, time and again, he was above all a constructor, one who, using elementary rules, researched the image for its space and flexibility. His line carrier, a product of strokes, is reminiscent of a toy figurine orientated to the right or left by a simple mechanism. The wondrous tightrope walker could himself be the creator of the delicate edifice. He has twisted a straight line into a bend and turned it into a gangplank. He might have designed a bridge, one suspects a pendulum; strings span from point to point. The rope alone creates perpetual motion out of nothing.

In 1920, Klee was appointed as a teacher at the Bauhaus school in Weimar, where his most productive artistic period was about to begin. The decisive 'school of the future' challenged him to also engage with the abstract and Constructivist work of his colleagues. In his *Pedagogical Sketchbook* he studies the visual alphabet. "The father of the arrow is the thought: How do I expand my reach? Over this river? This lake? That mountain?" In Klee's taxonomy, lines, volumes and colours always have an emotional dimension. It is very likely that this delicate tightrope structure is an answer to Theo van Doesburg's or Wassily Kandinsky's abstract compositions. The topic of balance, which will be part of the artistic dialogue far beyond the 1920s, inspires Klee to draw this encrypted self-portrait.

Fernand Léger (1881–1955)
La rue, 1907
Ink on paper, 34 × 27.5 cm

Stanislas Lépine (1835–1892)
Street, undated
Oil on wood, 30.5 × 40 cm

The wall as sundial It is not entirely clear where the narrow street, framed by two high walls, is leading. Treetops lean on the bright, whitewashed borders, hinting at private parks and fruit orchards. Straight ahead, there is a village centre quietly basking in the noonday of summer. The less we know where we are, the more intense the contrast between shadow and light. At first sight, nothing much is happening in Stanislas Lépine's views. Yet this only renders the bridges, streets and landscapes of provincial France more apt to have us explore all the subtle nuances of weather and temperature in their narrow brown palette. *Street* is a premonition. The shadows are growing longer, and once the all-pervasive sun passes on its way through the day to the West, nothing will be as before. The grass on the left will expand its darkness onto the right rim of the path, the firewall of the village's first house will lose its luminosity and the chestnut branch its grey tail on the wall.
The artist was looking very closely while he was adjusting his palette to the day. Lépine's landscapes are part of the tradition of the Barbizon School, that group of painters who left the studios of the academies for the forests of Fontainebleau in order to place more trust in their eyes than in tradition. Camille Corot was one of them, and Lépine learned from him.

Bernhard Luginbühl (1929–2011)
Popocatepetl/Bellevue, 1999
Lithograph, 65 × 50 cm

Henri Matisse (1869–1954)
Nadja regardant à droite, 1948
Aquatint, 50 × 40 cm

The truth is simple There is no sign of hesitation in the rendering of this woman. A single line captures the long pointed nose and the small closed mouth. A black trace frames the right half of the face, like the mask of a proud Egyptian woman, and there it restarts with a curl and the second eye. Thus, the same person is showing herself in close-up whilst at the same time seemingly lost in thought and far away. *Nadia* as someone familiar and *Nadia* the mystery remain in balance.
In July 2015, Nadia Kossiakov (née Sednaoui), now aged 90, spoke of her encounter with Henri Matisse. The rapport that formed from the first moment between Nadia, then a young woman, and the ageing master was more than a relationship between painter and model, she says. "It was a beautiful, harmonious friendship, truly very human. The idea of the model was of no relevance." Her presence was taken up very naturally by the artist's style. He sought to reveal the essential when capturing her face, as he did with all visible appearances. "Simplicity, maybe that is the truth."

Nadia had met Matisse in Paris in 1948 via his son-in-law, the art critic Georges Duthuit. His *chambre-atelier* allowed the ailing painter to work lying down. He had a unique gift of observation, Nadia records. She had felt how his gaze summarised what he saw, without insisting on verisimilitude. "Today with photography we can make such beautiful images, even in colour, that the painter's task is to supply what photography cannot provide." He never intended to render a precise reproduction of facial features. "A work of art has to contain its entire meaning inherently and reveal itself to the onlooker without their knowing its subject." The fact that she was not immediately recognisable on each sheet did not disturb Nadia. On the contrary: under Matisse's gaze she saw herself as free.

Joan Miró (1893–1983)
Les éclats du soleil blessent l'étoile tardive, 1951
Oil on canvas, 60 × 81 cm

Disarming spirits If there is one artist who managed to transfer ghosts and mythical creatures into modernity, it was Joan Miró. No one made the stars dance like him; no one was more loyal to the idea of playful invention – even when as painter, sculptor and ceramicist he had to deal with the drama of life in jeopardy. Bird, cloud, man and all hybrid creatures emerging from his line, point and colour are part of his universe, and each new image feels like the next and the one after; a glimpse into a world in which all elements fight for an equal right of existence. In weightless suspension, they share their space. He had "rediscovered art's childhood at the level of today's man", wrote Tristan Tzara in an edition of *Derrière le miroir* which the Maeght gallery dedicated to the Catalan painter in 1948.
The freedom with which Miró invites magic to his canvas was recognised as radical, even as revolutionary, as early as the 1920s. "Disarming" is what the Zurich newspaper *Neue Zürcher Zeitung* calls Miró's painting in the context of his 2016 exhibition at the Kunsthaus. Whether they are ladders, stars, eyelash animals or – as in his picture letter to Hulda – an elongated dachshund, small, dreamlike narrative impulses subvert the visible world.

Joan Miró has a special status within the art collection of Kronenhalle. And it is no accident. Gustav Zumsteg had undertaken a great deal in order to increase the awareness of the artist's work in the public perception within Zurich and Switzerland. He was responsible for Miró's introduction at the St. Gallen business school, where the artist created his 1965 wall frieze, and for the prominently placed ceramic for the Kunsthaus (1973). The reportage in the Swiss culture magazine *Du* of November 1976 must surely also have been instigated by the Kronenhalle, as the author Manuel Gasser was a friend of the house, the editorial office was around the corner and *Les éclats du soleil* a talking point at almost every table. Anyone who knows of interplanetary quarrels is ready for the pranks of the stars. Their mischief is thinly etched into the canvas or richly brushed across it. From *Les éclats du soleil,* at least seven pairs of eyes turn toward you, and everything competes to be both idea and matter.

Joan Miró
Figure (to Hulda Zumsteg on her birthday), 1969
Ink and watercolour on paper, 29 × 23 cm

Joan Miró
Landscape with moon and star, 1977
Oil on canvas, 27 × 22 cm

Joan Miró
Surrealist composition, 1979
Oil on canvas, 82 × 90 cm, dedicated on the back

Joan Miró
Picture letter (to Hulda Zumsteg on her 90th birthday), 1980
Mixed media on paper, 24 × 42 cm

Ernst Morgenthaler (1887–1962)
Landscape, 1917
Watercolour and charcoal on paper,
16.5 × 18 cm

Raymond Pettibon (*1957)
Untitled (You are licensed), undated
Pen and ink on paper, 75.5 × 56.5 cm

Robert Rauschenberg (1925–2008)
The jungle, 1989
Screen print, 122 × 92 cm

Pablo Picasso (1881–1973)
Peintre au travail, 1965
Oil on canvas, 62 × 51 cm

The painter is in the painting The mighty head meets the viewer's gaze with eyes, ears and nostrils. Has this person become feral? Is he afraid? Is he hiding? Lurking, observing and disturbed visions alternate in the same face, while a dark shadow below the right eye masks a calmer view. Whorls, waves and lines keep the face with its beard and hair under control, while the closed mouth hints at a brisk, perhaps patient attitude. "This face unites so much sensitivity and brutality – it is shocking." Gustav Zumsteg's own shock confirms the verdict of Gottfried Jedlicka, professor of art history at the University of Zurich and a regular guest at Kronenhalle. He called Picasso both a "shatterer and creator of worldviews", and in the Rämistrasse restaurant, he figures as both. While *Head,* created in the artist's last year of working, dispenses with portraiture in favour of a complex, human, male existence, the 1965 painting shows a softer figure. It looks like a blind man conversing with his picture. The painter is guiding his left hand to the canvas like a spiritual master. Each breath and each movement counts. Almost horizontal, the brush becomes the mediator between the creator and the work.

Pablo Picasso
Head, 1972
Crayon, watercolour and ink
on paper, 64.5 × 50 cm

Sigismund Righini
Sunset, 1914
Oil on cardboard, 18.5 × 24.5 cm

Sigismund Righini (1870–1937)
Still life of peaches, 1917
Oil on cardboard, 32 × 46 cm

At home when out The temperature at the lake transcends the painting. Sigismund Righini draws warmth for his evening landscape from the colour of the cardboard itself. Its ochre provides a contrast with the cool breeze of all the blue and grey hues while warm colours track the sky. The mountain in the centre lies like a stranded whale across a strip of pine-green. The miniature painting seems to have been tossed casually onto the board, and it is not the only study to prove Righini's quick perception. Technique and format reveal that this vision was captured with his wooden paintbox en plein air. France's legacy is tangible in his work. Righini's paintings are familiar with the Impressionist tradition and have absorbed knowledge of the Fauves and the Nabis. Righini, however, has made history not just as an artist but also as an art politician. His vast correspondence and activities as a jury member bear testimony to an emphatic and sometimes controversial advocacy for the interests of Swiss art. "Sometimes I thought he is more at home when he's not at home," is how his granddaughter Hanny Fries remembers him. At his bourgeois dinner table or overlooking the lake, he was both: seeking the grand form in the smallest of formats, he was completely in the world and in himself.

Auguste Rodin (1840–1917)
Female nude (Isadora Duncan), 1918
Pencil and watercolour on paper,
32 × 25 cm

Mimmo Rotella (1918–2006)
Footballer, undated
Collage on canvas, 89 × 67.5 cm

Everything is here – time to destroy it His tie flutters across his jacket. The brown ball has nearly reached the young man's head and casts a shadow over his face and neck. A brushstroke seems to give volume to the leather ball. And yet painting has had its day: a reactionary spirit lurks in its claim to originality , its significant achievements already made by others. Mimmo Rotella is demanding something new, something alive – for surfaces as the city itself presents them. In 1953, the artist, jazz musician and author of phonetic poetry returned to Rome after his sojourn in the US. Here, he ripped posters and advertisements from public walls in order to rearrange them in fragments on his canvas. "To tear posters down from the wall is my personal form of protest against a society that has lost its delight in change and its sense of imaginative transformation," he wrote in 1957, in the middle of the post-war economic boom. Sports, consumerism and spectacle invade Rotella's art. Whilst it absorbs the icons of popular culture, in arranging found items it simultaneously cultivates an aesthetic of decay.

Alex Sadkowsky (*1934)
Man at table, undated
Coloured etching, 10 × 14 cm

Chaïm Soutine (1893–1943)
Still life, 1923
Oil on canvas, 34 × 74 cm

Aroused food Dishes sway, the tabletop floats on the olive-coloured background like a boat on murky high water. The tomatoes are agitated; their dense juxtaposition could make the whole bowl boil over. The surrounding items closely eye the tomatoes' flesh, the beheaded green duck, the spider crab spreading its claws, even aubergine and fish submit to the pulling power of the battered metal bowl. Chaïm Soutine's still life is full of passionate temperament. It shamelessly slaughters animals and positions two useless spoons near the lower frame to make its point: such a painting has no use for polite table manners.

But not only fish, birds and fruit threw the late Expressionist Soutine into turmoil. He also ploughed his restless brushstroke through flowers, landscapes and portraits. From a scrawny chicken at the poultry shop to a particularly noble calf's head from the butcher, it is said the artist chose his subjects very carefully in order to appropriate them in a lonely, feverish act of painting. The Hungarian writer and art critic Emil Szittya wrote that Soutine was "flinging the colours onto the canvas like poisonous butterflies." He devoted himself to his paintings in an unreserved and corporeal manner, but never neglected compositional control.

Soutine's immediate circle in Paris noted that he was a man of curious habits. An aura of mystification surrounded his tragi-comic identity. Much has been written about the reasons for the inner fervour and existential importance of Soutine's art. Hunger could have been responsible for the son of a poor dressmaker's propensity for raw meat, poultry and ripe tomatoes, together with the harsh experiences of a Jewish childhood in an East European schtetl. An enthusiasm for van Gogh's dynamic brushstrokes plays a role, and perhaps too Soutine's own delicate stomach, which did not allow for heavy foods. When the American collector Albert C. Barnes bought Soutine's entire production from his stay in Céret in southern France in the early 1920s, the painter was finally free from financial struggles. He was to wrestle with the items on the canvas, however, for another twenty years.

Jean Tinguely (1925–1991)
Picture letter to Hulda Zumsteg
(on her 90th birthday), 1980
Collage and mixed media on paper,
29.5 × 21.5 cm

Jean Tinguely
Picture letter to Hulda Zumsteg, 1984
Collage and mixed media on paper,
25 × 35 cm

Jean Tinguely
Picture letter to Gustav Zumsteg, 1990
Collage and mixed media on paper,
37 × 55 cm

Henri de Toulouse-Lautrec
(1864–1901)
Hanging bird, 1876
Pencil on paper, 28 × 21.5 cm

Silent drama The bird is hanging on a thin thread. In a long caress, the pencil lines flatter its feathers, following its body from the bony little legs to the tip of the beak, also taking in its shadow on the wall. What initially seems to be a study by an old master is in fact a child's drawing. Henri de Toulouse-Lautrec was only 11 years old when he drew this snipe in 1876. Of course his picture is in the tradition of hunting still lifes. Is there also a hint in the lifeless prey toward the fainting spells that so often confined the ailing boy to his bed?

Nothing could have deterred him from his decision to embark on an artistic career. Small of stature, the descendant of French landed gentry learned the elementary steps of painting from an animal painter and friend of his father's. The precision with which he trained on the familiar subjects of the hunt and animals would later become the incorruptible eye with which he would capture the contours of his human models. His seismographic instinct led him to find his subjects at the theatre and the cabaret, in brothels and boudoirs, and his real home within bohemian Paris. He would draw and lithograph with a cool nonchalance that France had so far accepted only in caricature.

The snipe did have a role to play on the menus of the late nineteenth century. At the Kronenhalle, the bird reminds us that Toulouse-Lautrec was not only a gifted observer, but also a renowned gourmet.

Varlin (Willy Guggenheim) (1900–1970)
Hulda Zumsteg, 1967
Oil on canvas, 128 × 122 cm

Hulda remains Varlin's Hulda Zumsteg is a legacy. Gustav must have known that if his mother were present on a canvas before everyone's eyes, she would remain part of the conversation. Even more so, that she who had monitored every move on both sides of the counter for decades would remain a landlady for ever. With a twinkle in his eye – just like Madame Zumsteg herself – the painter undertook to immortalise her in 1967. He playfully circumnavigates with nonchalance and humour what could have become a burden. Like a master hairdresser, with a few brushstrokes above her forehead, he adds a stabilising glow to Hulda's rounded hairdo – and with a hint of red above her head, an aura that befits the elderly, sophisticated woman. He puts rouge on her cheeks, and he retains her amused mouth from her sittings in his Zurich studio. It is a smile that leaves unanswered whether Hulda's hand near her left eye is reaching for the familiar glasses or wiping away a tear of laughter. "At the neck and the other wrist, jewellery hints at the fact that here we have someone who was very much the architect of her own fortune," cites Dieter Bachmann in his appreciation of Hulda in 1984. And it is a signature of the artist too. Varlin always seeks to keep a balance between precise protocol and hyperbolic caricature. In one point, however, the painter remains firm: "The higher and lower strata of society receive the same painterly treatment; he depicts them all as representatives."

Varlin, born Willy Guggenheim, had to wait a long time for his success. During the heyday of abstract and pop art, public critics treated him with reserved respect. It was Swiss literary figures – among them Friedrich Dürrenmatt, Max Frisch and Jürg Federspiel – who made the "strange Zurich painter fellow" socially acceptable and known to collectors in the 1950s and 1960s. It seems logical that the Kronenhalle should play a part in Varlin's career, which tied him for years to his "loved and hated place of birth".

Yves Saint-Laurent affectionately called Madame Zumsteg a "night owl" when she celebrated her 90th birthday, 13 years after the creation of Varlin's portrait. "You choose the evening to appear in your empire of lights... attentive, you never miss a beat." As upright as possible, supported by a cane, she still enjoyed her performance at the brasserie tables. "Yet all of it done with gentleness, humour and the coquetry of a young girl, as if it were nothing."

Varlin (Willy Guggenheim)
Friedrich Dürrenmatt, 1967
Pen on paper, 40 × 28 cm

Félix Vallotton (1865–1925)
Bridge, 1917
Charcoal on paper, 25 × 19,5 cm

Edouard Vuillard (1868–1940)
The chef, undated
Pencil on paper, 17 × 11 cm

Robert Wenger (*1944)
Still life of paper bag and containers, undated
Oil on cardboard, 16.5 × 12 cm

Brasserie (ground floor)

1 → p. 93
Marc Chagall
Le coucher du soleil

2 → p. 90
Georges Braque
La plaine II

3 → p. 18
I. C. Fuesslin
Rudolphus Bruno
Copperplate engraving

4 → p. 95
Lyonel Feininger
Manhattan

5
Anton Graff
Samuel Gessner, c. 1784
Copperplate engraving

6 → p. 98
Giovanni Giacometti
Toeletta della sera

7 → p. 114
Chaïm Soutine
Still life

8
Portrait of Gustav Zumsteg
Photo: Gian Paolo Barbieri, 1972

9 → p. 109
Joan Miró
Landscape with moon and star

10
Portrait of Hulda Zumsteg
Photographer unknown

11 → p. 115
Henri de Toulouse-Lautrec
Hanging bird

12 → p. 20
Portrait of Georges Braque
Photographer unknown

13 → p. 100
Julio Gonzalez
Deux bouteilles

14
Portrait of Hulda Zumsteg in the wine cellar
Photographer unknown

15
Portrait of Signore Mazzola, Chef de service
Photographer unknown

16 → p. 113
Alex Sadkowsky
Man at table

17 → p. 109
Joan Miró
Figure

18 → p. 20
Portrait of James Joyce at Zurich's Platzspitz
Photographer unknown

Wall towards Chagall Room and hallway (East/Pfauen)

Graphic prints and photographs are included in the illustration (in grey) but not listed in the catalogue of works.

Wall towards the main entrance (West/Bellevue)

19 → p. 109
Joan Miró
Picture letter

20 → p. 89
Pierre Bonnard
La petite blanchisseuse

21 → p. 103
Wassily Kandinsky
Two girls

22 → p. 94
James Ensor
Pot plant

23 → p. 93
Marc Chagall
Bouquet

24 → p. 91
Georges Braque
Gros nuages

25 → S. 18
Karl Stauffer-Bern
Conrad Ferdinand Meyer von Zürich, 1887
Etching

26 → p. 115
Jean Tinguely
Picture letter

27
Arnold Böcklin
Gottfried Keller, 1889
Heliogravure

28 → p. 86
Pierre Alechinsky
Composition

29 → p. 116
Varlin
Hulda Zumsteg

30 → p. 117
Varlin
Friedrich Dürrenmatt

31
Portrait of Alexander Calder,
Photographer unknown

32
Portrait of James Joyce
Photographer unknown

33 → p. 86
Cuno Amiet
Portrait of James Joyce

34 → p. 94
Eduardo Chillida
Hand

35
Portrait of Friedrich Dürrenmatt
Photo Edouard Rieben, 1980

36 → p. 104
Anna Keel
Moritz Schumacher from Berlin

37
Portrait of Federico Fellini
Photographer unknown

38 → p. 94
Friedrich Dürrenmatt
Minotaur with a glass

39 → p. 111
Pablo Picasso
Peintre au travail

40 → p. 108
Joan Miró
Les éclats du soleil blessent l'étoile tardive

Chagall Room (ground floor)

Wall towards the hallway (South/Stadelhofen)

46 47 48

Window front (North/Rämistrasse)

51 52

End wall (East/Pfauen)

41 → p. 89
Pierre Bonnard
Nude

42 → p. 112
Auguste Rodin
Female nude

43 → p. 88
Pierre Bonnard
View from the window

44 → p. 106
Fernand Léger
La rue

45 → p. 103
Max Hunziker
Dialogue ou soliloque

46 → p. 106
Stanislas Lépine
Street

47 → p. 92
Marc Chagall
The clock as violinist

48 → p. 87
Max Billeter
Potato harvest

49 → p. 87
Joseph Beuys
Untitled

50
50 → S. 94
Theo van Doesburg,
Kurt Schwitters
Small Dada Soirée

51
Portrait of Hulda Zumsteg
Photographer unknown

52 → p. 117
Edouard Vuillard
The chef

53 → p. 117
Félix Vallotton
Bridge

54 → p. 93
Marc Chagall
Bouquet with lovers

55 → p. 89
Pierre Bonnard
Landscape

Wall towards the brasserie (West/Bellevue)

Swiss Gallery (first floor)

Wall towards the hallway (South/Stadelhofen)

Window front (North/Rämistrasse)

End wall (East/Pfauen)

56 → p. 112
Sigismund Righini
Still life of peaches

57 → p. 96
Augusto Giacometti
Birdcage

58 → p. 101
Max Gubler
Night

59 → p. 115
Jean Tinguely
Picture letter

60 → p. 94
Adolf Dietrich
Two squirrels

61 → p. 102
Ferdindand Hodler
Cherry trees

62 → p. 98
Giovanni Giacometti
Fanciulli nel lago

63 → p. 110
Ernst Morgenthaler
Landscape

64 → p. 98
Giovanni Giacometti
Sea of fog

65 → p. 99
Giovanni Giacometti
Mare di nebbia

66 → p. 103
Johannes Itten
Apples

67 → p. 96
Augusto Giacometti
Window

68 → p. 117
Robert Wenger
Still life

69 → p. 112
Sigismund Righini
Sunset

70 → p. 86
Assia
View from a window

71 → p. 87
Hans Berger
House with trees

72 → p. 100
Max Gubler
Self-portrait at the easel

73 → p. 104
Reinhold Kündig
Landscape

End wall (West/Bellevue)

Bar

Wall with main entrance (North/Rämistrasse)

Wall beside the bar (East/Pfauen)

Wall towards the hallway (West/Bellevue)

74 → p. 107
Henri Matisse
Nadja regardant à droite

75 → p. 105
Paul Klee
Tightrope walker

76 → p. 104
Anna Keel
The blue soda siphon

77 → p. 110
Robert Rauschenberg
The jungle

78, 79, 80, 81 → p. 97
Diego Giacometti
Lamps, pendant lamps
and tables

82
Summer 99
Graphic print,
artist unknown

83 → p. 93
Marc Chagall
Harlequin

84 → p. 109
Joan Miró
Surrealist composition

85 → p. 110
Raymond Pettibon
Untitled

86 → p. 115
Jean Tinguely
Picture letter

87 → p. 109
Joan Miró
Picture letter

88 → p. 111
Pablo Picasso
Head

**Not included in the
illustration but listed in the
catalogue of works are:**

Brasserie
Julio Gonzalez
Head
→ p. 100

Hallway bar – brasserie
Mimmo Rotella
Footballer
→ p. 113

**Cloakroom /
side entrance to bar**
Giovanni Giacometti
La notte I
→ p. 98

**Side entrance to bar /
hallway to kitchen**
Georges Braque
Vase and *Grande tête*
→ p. 91

Hallway first floor – staircase
Pierre Bonnard
La revue blanche
→ p. 89

Eduardo Chillida
Hand
→ p. 94

Bernhard Luginbühl
Popocatepetl / Bellevue
→ p. 106

Selected Bibliography

Archive of Abraham AG at the Swiss National Museum Zurich: Scrapbooks, Photographs of fashion design and samples of textiles 1947–1996.

Carlo Bernasconi and Peter Roth, *Kronenhalle Bar: Drinks & Stories,* Zurich: Orell Füssli Verlag, 2009.

Therese Bhattacharya-Stettler, Matthias Frehner and Beat Stutzer (eds.), *Giovanni Giacometti – Farbe im Licht* (exhib. cat., Berne, Kunstmuseum and Chur, Museum of Fine Arts), Zurich: Scheidegger & Spiess AG, 2010.

Gottfried Boehm, "Ferdinand Hodlers 'dekorative' Landschaften. Ein Gespräch vor Bildern", in: *Ferdinand Hodler – eine symbolistische Vision* (exhib. cat., Berne, Kunstmuseum and Budapest, Szépművészeti Múzeum), Ostfildern: Hatje Cantz, 2008, p. 217 f.

Dirk Boll (ed.), *Ein gastliches Kunstwerk. Die Kronenhalle und ihre Sammlung,* Ostfildern: Hatje Cantz, 2011.

Bettina Brand-Claussen and Peter Cornelius Claussen, *Max Gubler. Malen in der Krise. Das unbekannte Spätwerk,* Zurich: Scheidegger & Spiess AG, 2014.

Georges Braque, *Day and Night (Notebooks)* 1952.

Georges Braque, "Die Macht des Geheimnisses", in: *Vom Geheimnis in der Kunst – gesammelte Schriften* (Sammlung Horizont), Zurich: Arche, 1958, p. 71.

Nico Cadsky, Karin Giger and Michael Wissing (eds.), *Restaurant Kronenhalle Zürich,* Zurich: Orell Füssli Verlag AG, 2005.

Christie's (ed.), *Works from the Zumsteg Collection: Tuesday 27 June 2006,* Auction catalogue, Zurich 2006.

Siegfried Cremer, *Dufrêne, Hains, Rotella, Villeglé, Vostell: Plakatabrisse aus der Sammlung Cremer* (exhib. cat., Stuttgart, Staatsgalerie), 1971.

Derrière le miroir: La fondation Marguerite et Aimé Maeght à Saint Paul, Paris: Maeght Editeur, 1964.

Augusto Giacometti, "Die Farbe und ich", in: *Augusto Giacometti. Gemälde, Aquarelle, Pastelle, Entwürfe* (exhib. cat., Neuss, Clemens-Sels-Museum), 1987.

F. Hauswirth, "Ein Treffpunkt der kulturellen Welt", in: *Zürcher Chronik* no. 3/1976, p. 142 f.

Ich bin an wenigen Orten daheim – die Zürcher Kronenhalle in Geschichten, Frankfurt am Main: Weissbooks, 2010.

Gotthard Jedlicka, *Pariser Tagebuch,* Frankfurt am Main: Suhrkamp, 1961.

Gotthard Jedlicka: *Pierre Bonnard – ein Besuch,* Erlenbach-Zürich: Eugen Rentsch Verlag, 1949.

Rudolf Koella, *Sigismund Righini. Maler, Zeichner, Kunstpolitiker,* Zurich: Offizin Zürich Verlags AG, 1993.

Kronenhalle, Typescript with the history of the building, Office for the Preservation of Historic Monuments, Zurich, undated.

Kronenhalle 1862 – 1922 – 1962 (Festschrift on the occasion of the 100-year anniversary of the Kronenhalle Zurich), Zurich 1962.

Kathrin Künzi, "Max Gubler – Grenzgänger", in: *Max Gubler* (exhib. cat., Schaffhausen, Museum zu Allerheiligen and Solothurn, Museum of Fine Arts), 1998, pp. 12–32.

Kunsthaus Zurich (ed.), *Chagall* (exhib. cat.), Zurich 1967.

Kunsthaus Zurich (ed.), *Geschenke und Neuerwerbungen zum 220-Jahr-Jubiläum der Zürcher Kunstgesellschaft,* (exh. brochure), Zurich 1988.

Kunsthaus Zürich (ed.), *Saal Marc Chagall,* Brochure printed on the occasion of the opening on 17 November 1973.

Das Magazin (Tages-Anzeiger) no. 44, 2002: *Eine Frage des Stils – Die Kronenhalle und die Zumstegs* (Text: Franziska K. Müller / Photos: Daniel Sutter).

Henri Matisse, Traits essentiels. Gravures et monotypes (exhib. cat., Geneva, Cabinet des estampes), 2006.

Meret Meyer, Preface for *Voyages et rencontres de Marc Chagall 1923–1939,* Musée National Message Biblique Marc Chagall, Nice 1998.

Joan Miró, 12 Letters to Gustav Zumsteg (1961–1973), including drawings in colour, Zurich Central Library, Manuscript Department (MS. Z VI 512).

Ingrid Mössinger and Kerstin Drechsel, *Lyonel Feininger: Loeberman Collection: Drawings, Watercolors, Prints* (exhib. cat., Chemnitz, Kunstsammlungen), Munich: Prestel, 2006.

Galerie Motte, *Christian Bérard – L'enchanteur de Paris* (exhib. brochure), Geneva, May 1949.

Markus Müller (ed.): *Maeght. Das Abenteuer der Moderne* (exhib. cat., Münster, Kunstmuseum Pablo Picasso), 2008.

Willy Rotzler: *Die Geschichte der Alberto Giacometti-Stiftung,* Berne: Benteli-Verlag, 1982.

Ernst Scheidegger (ed.), *Das Bergell. Heimat der Giacometti,* Zurich: Verlag Ernst Scheidegger, 1994.

Swiss National Museum Zurich (ed.), *Soie Pirate* (vol. 1: The History of Abraham Ltd., vol 2: The Fabric Designs of Abraham Ltd., Zurich: Scheidegger & Spiess AG, 2010.

Jacqueline von Sprecher, *Diego Giacometti tritt aus dem Schatten,* (exhib. cat.,Gelbes Haus Flims), Zurich: Neue Zürcher Zeitung, 2007.

Maurice Tuchman and Esti Dunow, "Soutine at Work", in: *Chaïm Soutine – The Passion of Painting* (exhib. cat., Munich, Galerie Thomas), 2009, p. 15 f.

Ludmila Vachtova: *Varlin* (with contributions by Friedrich Dürrenmatt, Max Frisch, Jürg Federspiel, Manuel Gasser, Hugo Loetscher, Paul Nizon, Giovanni Testori and Varlin), Frauenfeld 1978.

Zürcher Kunstgesellschaft (ed.), *Joan Miró – Mauer, Fries, Wandbild* (exhib. cat. Zurich, Kunsthaus), Munich: Hirmer, 2015.

Gustav Zumsteg (ed.), *Briefe an Hulda Zumsteg (Zum 90. Geburtstag),* Zurich 1980.

Copyright Notes

Photographs from the Kronenhalle

Photographic Essays (cover, pp. 40–57, 64–77) © Christian Flierl
Still lifes (back cover, pp. 10–15, 34–39, 58–63, 78–83) © Donata Ettlin

History of the Collection

p. 20
left: © Koller auctions, Zurich

p. 21
left: Pierre Bonnard, *Nuages sur les toits* (ca. 1920) © Christie's Images Limited (2006) | centre: © Galerie Maeght, Paris | right: © 2018, ProLitteris, Zurich

p. 22
left: © bpk / CNAC-MNAM / Fonds Marc Vaux | right: © The Life Picture Collection / Photo: Dmitri Kessel / Getty Images

p. 23
Abraham archives, Swiss National Museum, upper left: LM-114430.3 | centre left: LM-110496.5 | above right: LM-110496.6 | centre right: LM-113606.17 | bottom: LM-112077.17 © Association Willy Maywald / 2018, ProLitteris, Zurich (fashion design: Pierre Balmain 1950)

p. 24
left: Jean Bazaine, *Midi. Arbres et rochers* (1952) © 2018, ProLitteris, Zurich / Kunsthaus Zürich | bottom: © ETH Library, Zurich, Picture archives / Photograph: Comet Photo AG (Zurich) / Com_L10-0309-0011-0023 / CC BY-SA 4.0 | top centre: Georges Braque, *La palette* (1950) © 2018, ProLitteris, Zurich / Christie's Images Limited (2006) | top right: Joan Miró, Picture letter (1970) © Successió Miró / 2018, ProLitteris, Zurich | bottom right: Marc Chagall, *Le peintre et son chevalet* (1959) © 2018, ProLitteris, Zurich / Christie's Images Limited (2006)

p. 25
top left: © Photo archives Fondation Maeght | bottom left: © Galerie Maeght, Paris / Photo: Claude Gaspari © Succession Alberto Giacometti / 2018, ProLitteris, Zurich | right: © Photo Jacques Gomot – Archives Fondation Maeght

p. 26
left: © City of Zurich architectural history archives / Photo: Gottfried Gloor | centre: © 2018, ProLitteris, Zurich / Photo: Franco Cianetti | top: Henri Matisse, *Les huîtres* (1941) © Succession H. Matisse / 2018, ProLitteris, Zurich / Christie's Images Limited (2006)

p. 27
top: Marc Chagall, *La fenêtre sur l'Ile de Bréhat* (1924) © 2018, ProLitteris, Zurich / Kunsthaus Zürich

Acknowledgements

p. 28
left: Joan Miró, *Oiseaux qui s'envolent* (1971/1972) © 2018, ProLitteris, Zurich / Kunsthaus Zürich | right: © Photographic archive F. Català-Roca – Arxiu Fotogràfic del Col·legi d'arquitectes de Catalunya | Successió Joan Miró / 2018, ProLitteris, Zurich

p. 29
top: Marc Chagall, *Les Glaïeuls* (1955–1956) © 2018, ProLitteris, Zurich / Christie's Images Limited (1995) | left: © Franco Cianetti

p. 30
bottom centre: © © Fondation Pierre Bergé – Yves Saint Laurent, Paris / The Metropolitan Museum of Art, NY / Design: Jeffrey Daly

p. 31
above: Henri Matisse, *Branche de lierre* (1916) © Succession H. Matisse / 2018, ProLitteris, Zurich | left: Georges Braque, *Plat de fruits, cruche et couteau* (1926) © 2018, ProLitteris, Zurich / Kunsthaus Zürich | right: © Picture Press / Tom Jacobi / Stern | bottom: Chaïm Soutine, *Nature morte à l'artichaut* (around 1916) © 2018, ProLitteris, Zurich / Kunsthaus Zürich

p. 32
top left: © Keystone / Magnum / René Burri / 2018, ProLitteris, Zurich | bottom left: Pablo Picasso, *Tête de femme* (1906) © Succession Picasso / 2018, ProLitteris, Zurich / Christie's Images Limited (1995) | top right: Joan Miró, *La table (Nature morte au lapin)* (1921) © 2018, ProLitteris, Zurich / Christie's Images Limited (1995) | bottom right: © Keystone / Magnum / René Burri / © Succession Picasso / 2018, ProLitteris, Zurich

© 2018, ProLitteris, Zurich / for all other works

Unless otherwise stated, all original images are property of the Hulda and Gustav Zumsteg Foundation, Zurich. Not listed are credits for images whose owner could not be established.

Catalogue of works

Works by Pierre Alechinsky (p. 86), Joseph Beuys (p. 87), Georges Braque (pp. 43, 53, 90–91), Marc Chagall (pp. 72, 92–93), Eduardo Chillida (p. 94), Adolf Dietrich (p. 94), James Sidney Edward Ensor (pp. 68, 94), Lyonel Feininger (pp. 11, 95), Diego Giacometti (pp. 54–55, 57, 60, 77, 97), Johannes Itten (p. 103), Fernand Léger (p. 106), Mimmo Rotella (p. 113), Jean Tinguely (pp. 45, 115): © 2018, ProLitteris, Zurich
Artwork by Cuno Amiet (p. 86) © D. Thalmann, Aarau, Switzerland
Photo by Gian Paolo Barbieri (p. 37) © Gian Paolo Barbieri courtesy of Fondazione Gian Paolo Barbieri, Milano
Artwork by Hans Berger (p. 81, 87) © Anne Berger

Artwork by Friedrich Dürrenmatt (p. 94) © CDN / Swiss Confederation
Artworks by Max Gubler (pp. 39, 45, 83, 100, 101) © Eduard, Ernst and Max Gubler Foundation, Zurich
Artwork by Max Hunziker (p. 103): By friendly permission of Ursula Kunz
Artworks by Anna Keel (p. 104): © Jakob and Philipp Keel Collection
Artwork by Reinhold Kündig (p. 104) © Families Alther, Ambühl and Anderson
Artwork by Bernhard Luginbühl (p. 106) © Bernhard Luginbühl Foundation, Mötschwil / Basil Luginbühl
Artwork by Henri Matisse (pp. 55, 107) © Succession H. Matisse / 2018, ProLitteris, Zurich
Artworks by Joan Miró (cover, pp. 41, 47, 60, 68, 78, 108–109) © Successió Miró / 2018, ProLitteris, Zurich
Artwork by Ernst Morgenthaler (pp. 48, 110) © Estate of Ernst Morgenthaler
Artwork by Raymond Pettibon (pp. 54, 110) © Raymond Pettibon
Artworks by Pablo Picasso (pp. 47, 55, 61, 111) © Succession Picasso / 2018, ProLitteris, Zurich
Artwork by Robert Rauschenberg (pp. 79, 110) © Robert Rauschenberg Foundation / 2018, ProLitteris, Zurich
Artwork by Alex Sadkowsky (p. 113) © Alex Sadkowsky
Artworks by Varlin (Willy Guggenheim) (pp. 67, 116, 117) © P. Guggenheim, 7606 Bondo
Artwork by Robert Wenger (p. 117) © Robert Wenger

The Hulda and Gustav Zumsteg Foundation and the editors of this book have made every effort to identify all copyright owners and to receive their permission. Where copyright owners have been overlooked, we ask relevant parties to contact the Hulda and Gustav Zumsteg Foundation.

We should like to thank

the Hulda and Gustav Zumsteg Foundation
for their trust, special opening hours and access to information and archive documents;

Marius Casanova, the Hulda and Gustav Zumsteg Foundation, Donata Ettlin, Christian Flierl and Serge Hasenböhler
for their outstanding collaboration;

Nuray Arican, Giuseppe Cammisa, Giuliano Grazioli, Kimberley Gyger, Ariful Hoque, Fatma Kocak, Marianne Kulmer, Anthony Kunz and Diego Rico
for their assistance during the photo shoots;

Martina Böhler, Ursula Degen, Donata Ettlin, Ricarda Gerosa, Philipp Grünenfelder, Charlotte Wirthlin and the Platanenhof Basel
for their assistance during the test shoots;

Regine Bungartz, Donata Ettlin, Sonja Feldmeier, Giovanna Graf and Andrea Gruber
for their valuable support and second opinions;

Roberto Negrini
for sharing his memories;

Manuel Bürgin, the Theater Winkelwiese, Heike Dürscheid, the Stück Labor Basel, Ursina Greuel and the sogar theater
for their recommendations regarding contemporary playwrights;

Thomas Bochet, Andrea Franzen, Andrea Kunz, Swiss National Museum, Mirjam Brunner, Amt für Städtebau Archäologie & Denkmalpflege, City of Zurich; Philippe Büttner, Franca Candrian, Karin Marti, Kunsthaus Zürich; Sabine Faust, Keystone; Gitti Hug, Zürcher Kunstgesellschaft; Hans-Peter Keller, Christie's Zurich; Florence Monnier, Fondation Marguerite et Aimé Maeght; Swantje Redlin, Picture Press Bild- und Textagentur GmbH; François Roux, La Colombe d'Or, Saint-Paul-de-Vence; Monica Seidler-Hux, Central Library, Zurich: Manuscript Department
for their research support and information;

Sara Dreifuss and David Horák, Lawyer's office Horák, Zurich
for copyright clarifications regarding pictures;

Katharina Haderer, Andrea Bartelt-Gering, Cilly Klotz and Prestel Verlag, Munich
for their publishing expertise.

This publication was commissioned by the Hulda and Gustav Zumsteg Foundation, Zurich.

Conceived and edited by Sibylle Ryser and Isabel Zürcher
Art director and head visual concept: Sibylle Ryser, www.sibylleryser.ch
Research and text editor: Isabel Zürcher, www.isabel-zuercher.ch

Texts catalogue of works and collection history: Isabel Zürcher
Scenes for the Kronenhalle: Renata Burckhardt, Michael Fehr, Reto Finger, Ariane Koch
Translation factual texts: Bigna Pfenninger
Translation literary texts: Paul Day
Proof-Reading Michael Fehr: Fredy Bünter

Photographic essays: Christian Flierl, www.flierl.ch
Photography still lifes: Donata Ettlin, www.donataettlin.com
Photographs of art works: Serge Hasenböhler
Illustration: Sarah Weishaupt
Assistant art direction photo shoots: Donata Ettlin
Design and typesetting: Sibylle Ryser
Fonts: Gotham, Lexicon
Paper: Profibulk 150 gm², EOS Werkdruck 60 gm²

Verlagsgruppe Random House FSC® N001967

© Prestel Verlag,
Munich · London · New York, 2019
a member of Verlagsgruppe Random House GmbH
Neumarkter Strasse 28 · 81673 Munich
Prestel Publishing Ltd., 14–17 Wells Street,
London W1T 3PD
Prestel Publishing, 900 Broadway, Suite 603,
New York, NY 10003, USA

© Text: Renata Burckhardt, Michael Fehr, Reto Finger, Ariane Koch, Isabel Zürcher

The publisher explicitly states that external links contained in the text were reviewed by the publisher only up until the printing deadline. The publisher has no influence over subsequent changes and is therefore exempt from liabilities in this regard.

Overall production: Prestel Verlag, Munich
Project management: Andrea Bartelt-Gering
Copy-editing English: Jane Michael, Munich
Production: Cilly Klotz
Picture editing: Fredi Zumkehr, Bildpunkt AG, www.bildpunktag.ch
Lithography: Helio Repro, Munich
Printing and binding: Kösel GmbH & Co. KG, Altusried-Krugzell

Printed in Germany

ISBN 978-3-7913-5848-2 (English edition)
ISBN 978-3-7913-5847-5 (German edition)

www.prestel.com